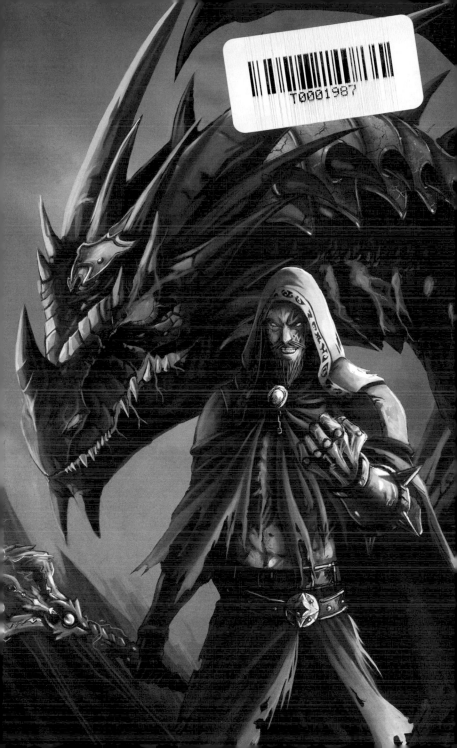

World Of Warcraft: Shadow Wing Vol. 2
Story by: Richard A. Knaak
Art by: Jae-Hwan Kim

Layout & Lettering - Erika Terriquez
Creative Consultant - Michael Paolilli
Cover Designer - Louis Csontos
Cover Artist - Jae-Hwan Kim
Cover Art & Colors Retouch - Michael Paolilli
Cover Designer - Arnett Taylor

Editors - Troy Lewter and Paul Morrissey
Editorial Translator - Janice Kwon
Print Production Manager - Lucas Rivera
Managing Editor - Vy Nguyen
Senior Designer - Louis Csontos
Art Director - Al-Insan Lashley
Director of Sales and Manufacturing - Allyson De Simone
President and C.O.O. - John Parker
C.E.O. and Chief Creative Officer - Stu Levy

BLIZZARD ENTERTAINMENT
Senior Vice President, Creative Development - Chris Metzen
Director, Creative Development - Jeff Donais
Lead Developer, Licensed Products - Mike Hummel
Publishing Lead, Creative Development - Micky Neilson
Senior Story Developer - James Waugh
Art Director - Glenn Rane
Director, Global Business
Development and Licensing - Cory Jones
Historian - Evelyn Fredericksen
Additional Development - Samwise Didier, Cameron Dayton and
Tommy Newcomer and Max Thompson

gear.blizzard.com

Library of Congress Cataloging-in-Publication Data available.

This book contains material originally published by TOKYOPOP Inc.

First Blizzard Entertainment printing: March 2011
Reprinting: October 2022

ISBN: 978-1-956916-04-1

10 9 8 7 6 5 4 3 2 1
Printed in China

WORLD OF WARCRAFT®
SHADOW WING™

VOLUME TWO

NEXUS POINT

STORY BY
RICHARD A. KNAAK

ART BY
JAE-HWAN KIM

BLIZZARD®

ENTERTAINMENT

WORLD OF WARCRAFT
SHADOW WING

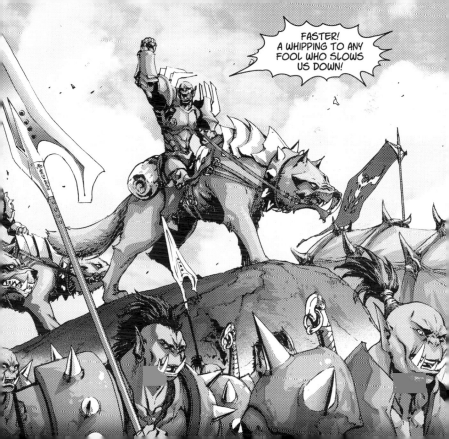

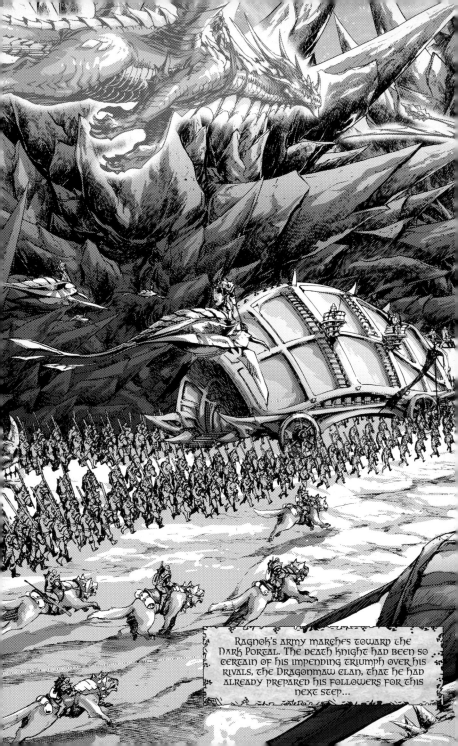

RAGNOK'S ARMY MARCHES TOWARD THE
DARK PORTAL. THE DEATH KNIGHT HAD BEEN SO
CERTAIN OF HIS IMPENDING TRIUMPH OVER HIS
RIVALS, THE DRAGONMAW CLAN, THAT HE HAD
ALREADY PREPARED HIS FOLLOWERS FOR THIS
NEXT STEP...

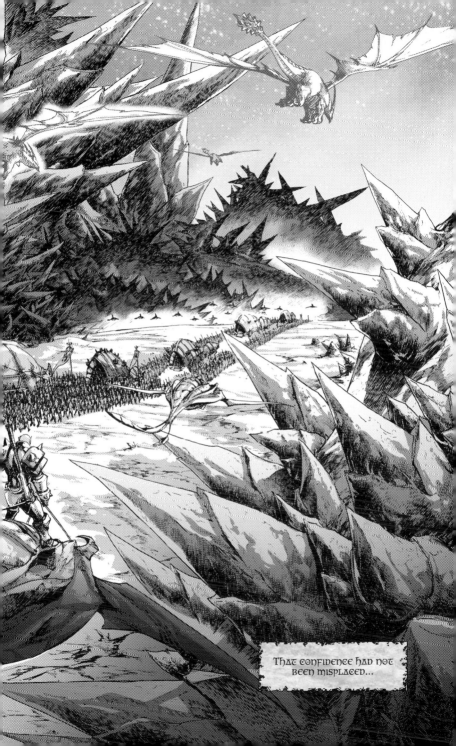

THAT CONFIDENCE HAD NOT
BEEN MISPLACED...

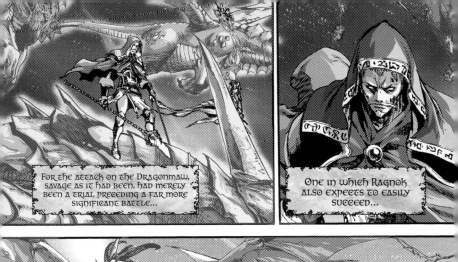

FOR THE ATTACK ON THE DRAGONMAW, SAVAGE AS IT HAD BEEN, HAD MERELY BEEN A TRIAL PRECEDING A FAR MORE SIGNIFICANT BATTLE...

ONE IN WHICH RAGNOK ALSO EXPECTS TO EASILY SUCCEED...

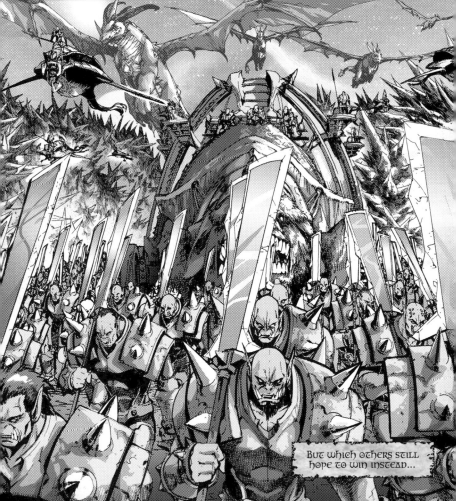

BUT WHICH OTHERS STILL HOPE TO WIN INSTEAD...

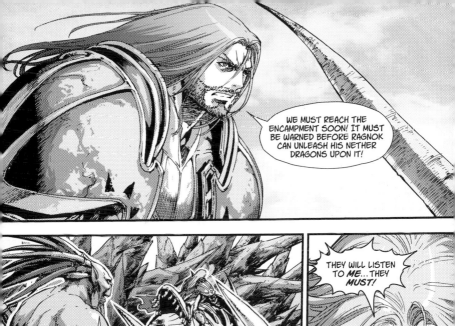

WE MUST REACH THE ENCAMPMENT SOON! IT MUST BE WARNED BEFORE RAGNOK CAN UNLEASH HIS NETHER DRAGONS UPON IT!

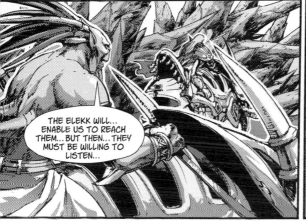

THE ELEKK WILL... ENABLE US TO REACH THEM... BUT THEN... THEY MUST BE WILLING TO LISTEN...

THEY WILL LISTEN TO *ME*... THEY *MUST*!

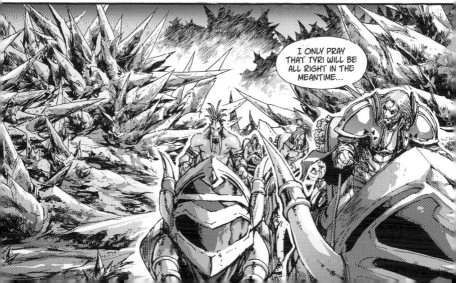

I ONLY PRAY THAT TYRI WILL BE ALL RIGHT IN THE MEANTIME...

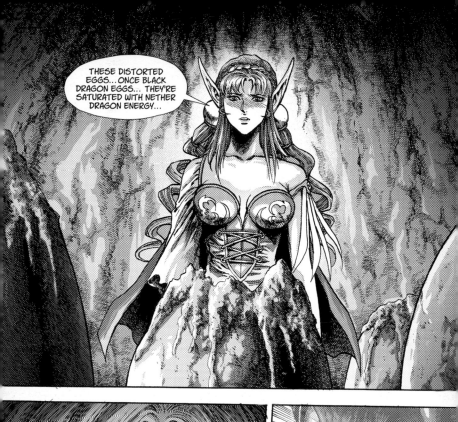

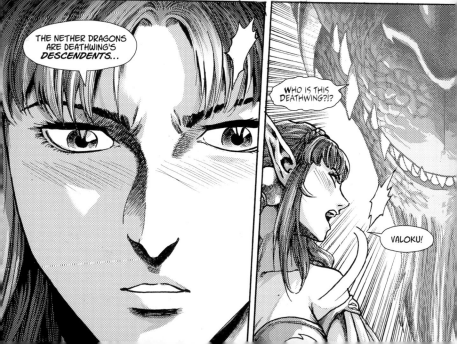

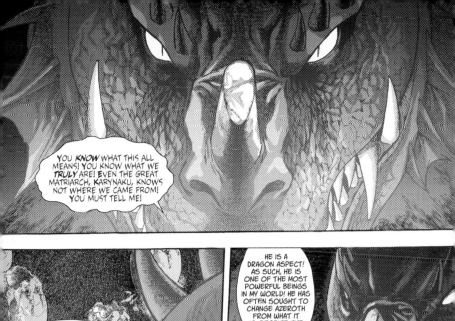

YOU **KNOW** WHAT THIS ALL MEANS! YOU KNOW WHAT WE **TRULY** ARE! EVEN THE GREAT MATRIARCH, KARYNAKU, KNOWS NOT WHERE WE CAME FROM! YOU MUST TELL ME!

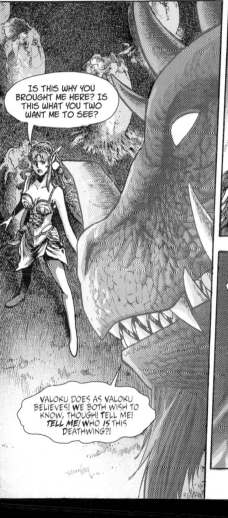

IS THIS WHY YOU BROUGHT ME HERE? IS THIS WHAT YOU TWO WANT ME TO SEE?

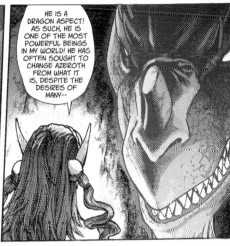

HE IS A DRAGON ASPECT! AS SUCH, HE IS ONE OF THE MOST POWERFUL BEINGS IN MY WORLD! HE HAS OFTEN SOUGHT TO CHANGE AZEROTH FROM WHAT IT IS, DESPITE THE DESIRES OF MANY--

THERE IS SOMETHING YOU HIDE! I KNOW IT! I **HEAR** IT IN YOUR VOICE, YOUR CAREFUL WORDS! TELL THE TRUTH! I **WILL** KNOW IT!

VALOKU DOES AS VALOKU BELIEVES! WE BOTH WISH TO KNOW, THOUGH! TELL ME! **TELL ME!** WHO IS THIS DEATHWING?!

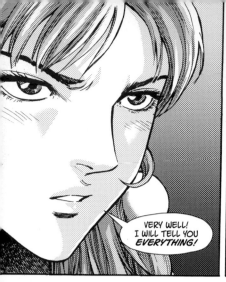

VERY WELL! I WILL TELL YOU *EVERYTHING!*

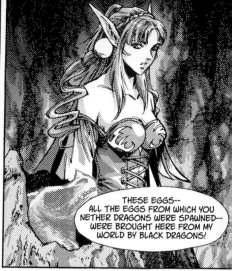

THESE EGGS-- ALL THE EGGS FROM WHICH YOU NETHER DRAGONS WERE SPAWNED-- WERE BROUGHT HERE FROM MY WORLD BY BLACK DRAGONS!

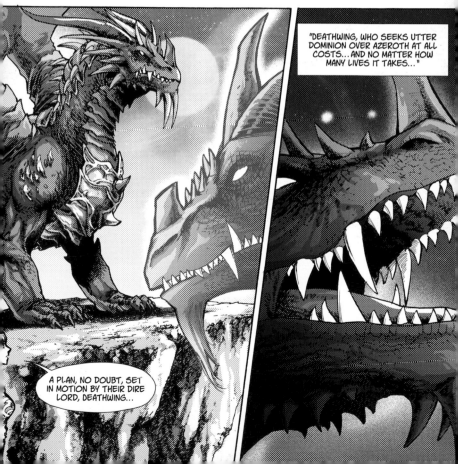

"DEATHWING, WHO SEEKS UTTER DOMINION OVER AZEROTH AT ALL COSTS... AND NO MATTER HOW MANY LIVES IT TAKES..."

A PLAN, NO DOUBT, SET IN MOTION BY THEIR DIRE LORD, DEATHWING...

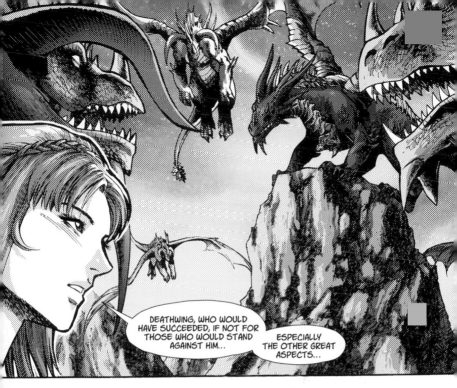

DEATHWING, WHO WOULD HAVE SUCCEEDED, IF NOT FOR THOSE WHO WOULD STAND AGAINST HIM...

ESPECIALLY THE OTHER GREAT ASPECTS...

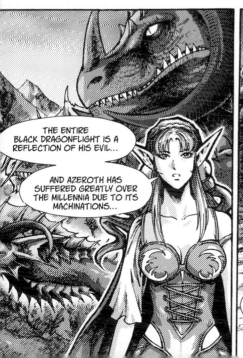

THE ENTIRE BLACK DRAGONFLIGHT IS A REFLECTION OF HIS EVIL...

AND AZEROTH HAS SUFFERED GREATLY OVER THE MILLENNIA DUE TO ITS MACHINATIONS...

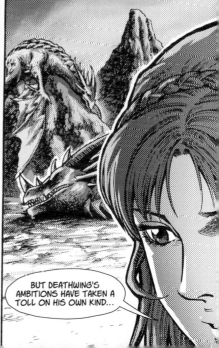

BUT DEATHWING'S AMBITIONS HAVE TAKEN A TOLL ON HIS OWN KIND...

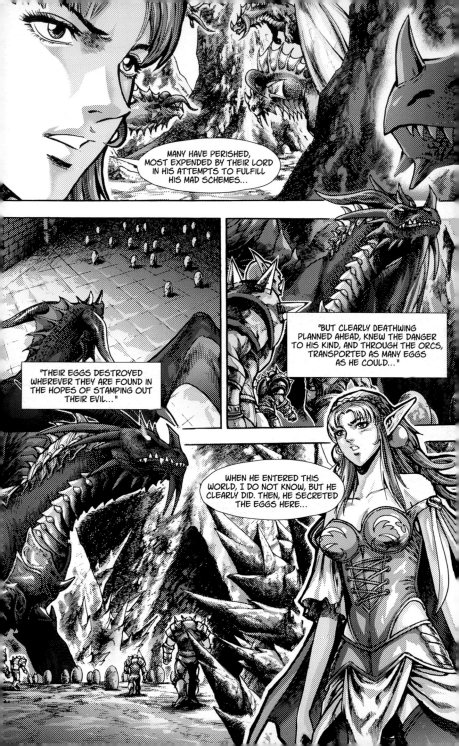

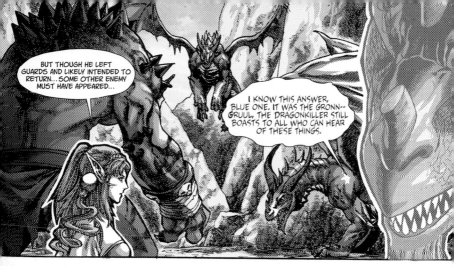

BUT THOUGH HE LEFT GUARDS AND LIKELY INTENDED TO RETURN... SOME OTHER ENEMY MUST HAVE APPEARED...

I KNOW THIS ANSWER, BLUE ONE. IT WAS THE GRONN-GRUUL, THE DRAGONKILLER STILL BOASTS TO ALL WHO CAN HEAR OF THESE THINGS.

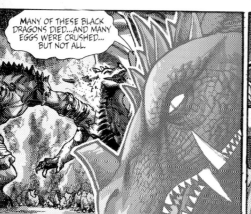

MANY OF THESE BLACK DRAGONS DIED...AND MANY EGGS WERE CRUSHED... BUT NOT ALL.

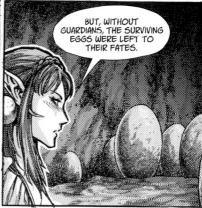

BUT, WITHOUT GUARDIANS, THE SURVIVING EGGS WERE LEFT TO THEIR FATES.

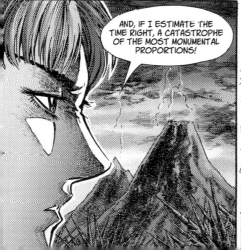

AND, IF I ESTIMATE THE TIME RIGHT, A CATASTROPHE OF THE MOST MONUMENTAL PROPORTIONS!

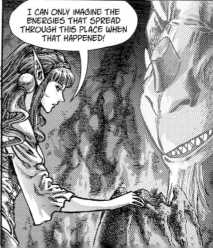

I CAN ONLY IMAGINE THE ENERGIES THAT SPREAD THROUGH THIS PLACE WHEN THAT HAPPENED!

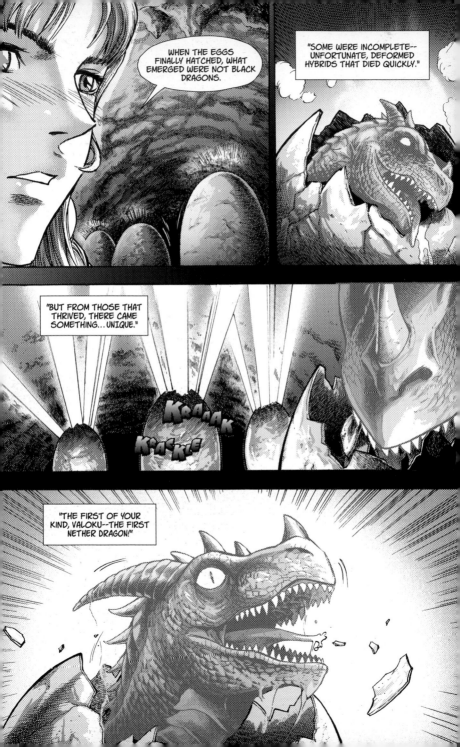

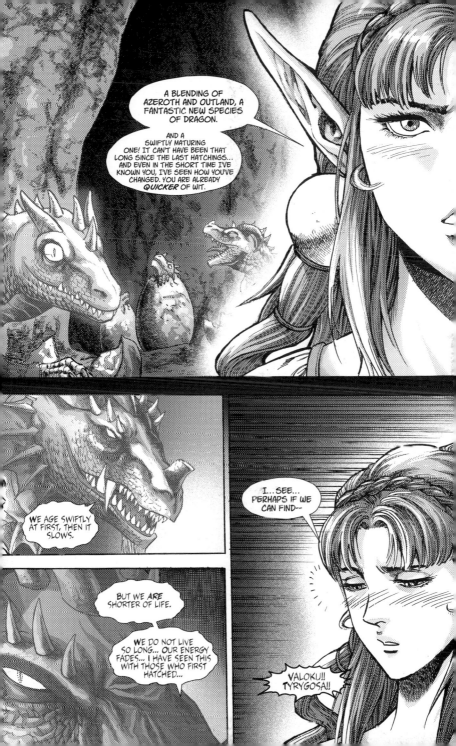

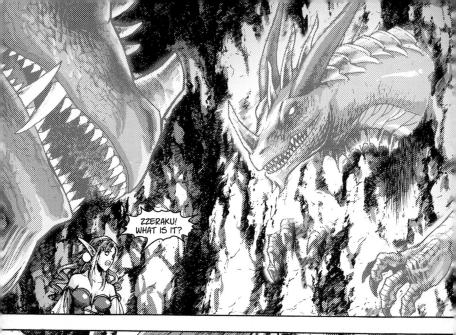

ZZERAKU! WHAT IS IT?

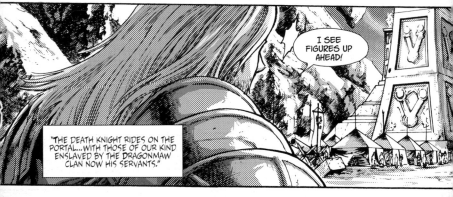

I SEE FIGURES UP AHEAD!

"THE DEATH KNIGHT RIDES ON THE PORTAL...WITH THOSE OF OUR KIND ENSLAVED BY THE DRAGONMAW CLAN NOW HIS SERVANTS."

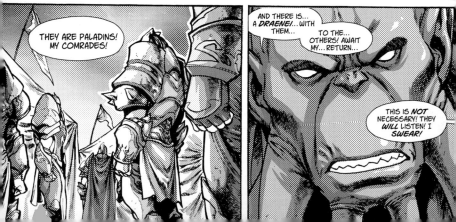

THEY ARE PALADINS! MY COMRADES!

AND THERE IS... A *DRAENEI*...WITH THEM...

TO THE... OTHERS! AWAIT MY... RETURN...

THIS IS *NOT* NECESSARY! THEY *WILL* LISTEN! I *SWEAR!*

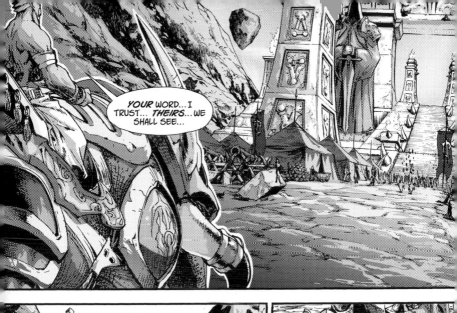

YOUR WORD... I TRUST... THEIRS... WE SHALL SEE...

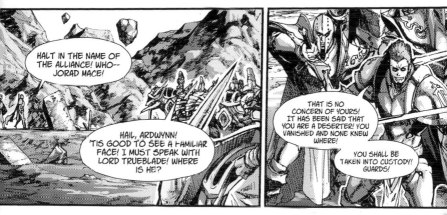

HALT IN THE NAME OF THE ALLIANCE! WHO-- JORAD MACE!

HAIL, ARDWYNN! 'TIS GOOD TO SEE A FAMILIAR FACE! I MUST SPEAK WITH LORD TRUEBLADE! WHERE IS HE?

THAT IS NO CONCERN OF YOURS! IT HAS BEEN SAID THAT YOU ARE A DESERTER! YOU VANISHED AND NONE KNEW WHERE!

YOU SHALL BE TAKEN INTO CUSTODY!! GUARDS!

!!!

STOP THIS FOOLISHNESS!

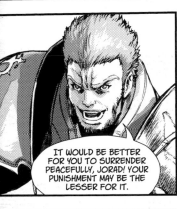

IT WOULD BE BETTER FOR YOU TO SURRENDER PEACEFULLY, JORAD! YOUR PUNISHMENT MAY BE THE LESSER FOR IT.

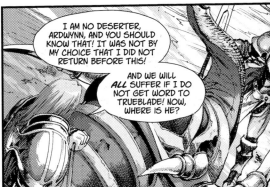

I AM NO DESERTER, ARDWYNN, AND YOU SHOULD KNOW THAT! IT WAS NOT BY MY CHOICE THAT I DID NOT RETURN BEFORE THIS!

AND WE WILL *ALL* SUFFER IF I DO NOT GET WORD TO TRUEBLADE! NOW, WHERE IS HE?

HE IS EVEN NOW IN CONFERENCE WITH COMMANDER DURON IN HIS TENT.

BUT THOUGH I MIGHT TAKE YOU AT YOUR WORD, JORAD, YOU'LL CERTAINLY GO NO FARTHER UNTIL YOUR COMPANION'S ALSO BEEN ACCOUNTED FOR.

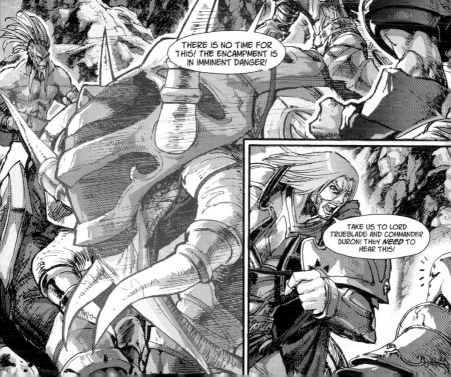

TELL YOUR TALE AND I'LL RELAY IT TO THE OFFICER ON DUTY! HE'LL DETERMINE WHETHER YOU REMAIN FREE, MUCH LESS SEE HIS LORDSHIP.

I TELL YOU THERE IS NO TIME FOR ALL THAT!

NO TIME FOR WHAT?

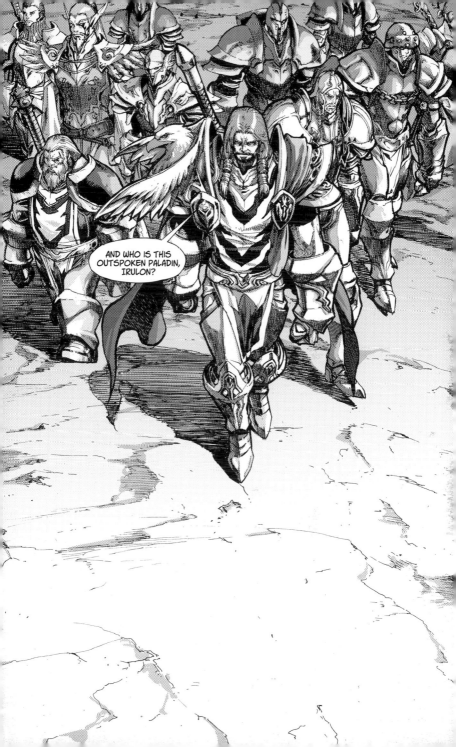

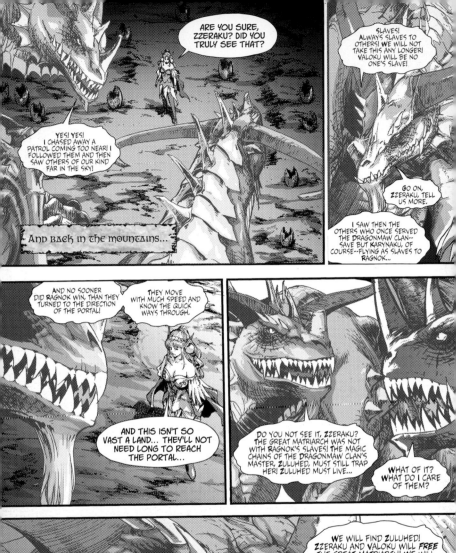

ARE YOU SURE, ZZERAKU? DID YOU TRULY SEE THAT?

SLAVES! ALWAYS SLAVES TO OTHERS! WE WILL NOT TAKE THIS ANY LONGER! VALOKU WILL BE NO ONE'S SLAVE!

YES! YES! I CHASED AWAY A PATROL COMING TOO NEAR! I FOLLOWED THEM AND THEN SAW OTHERS OF OUR KIND FAR IN THE SKY!

GO ON, ZZERAKU, TELL US MORE.

I SAW THEN THE OTHERS WHO ONCE SERVED THE DRAGONMAW CLAN-- SAVE BUT KARYNAKU, OF COURSE--FLYING AS SLAVES TO RAGNOK...

And back in the mountains...

AND NO SOONER DID RAGNOK WIN, THAN THEY TURNED TO THE DIRECTION OF THE PORTAL!

THEY MOVE WITH MUCH SPEED AND KNOW THE QUICK WAYS THROUGH.

AND THIS ISN'T SO VAST A LAND... THEY'LL NOT NEED LONG TO REACH THE PORTAL...

DO YOU NOT SEE IT, ZZERAKU? THE GREAT MATRIARCH WAS NOT WITH RAGNOK'S SLAVES! THE MAGIC CHAINS OF THE DRAGONMAW CLAN'S MASTER, ZULUHED, MUST STILL TRAP HER! ZULUHED MUST LIVE...

WHAT OF IT? WHAT DO I CARE OF THEM?

WE WILL FIND ZULUHED! ZZERAKU AND VALOKU WILL *FREE* THE GREAT MATRIARCH! *WE* WILL BE *GREATEST* AMONG NETHER DRAGONS!

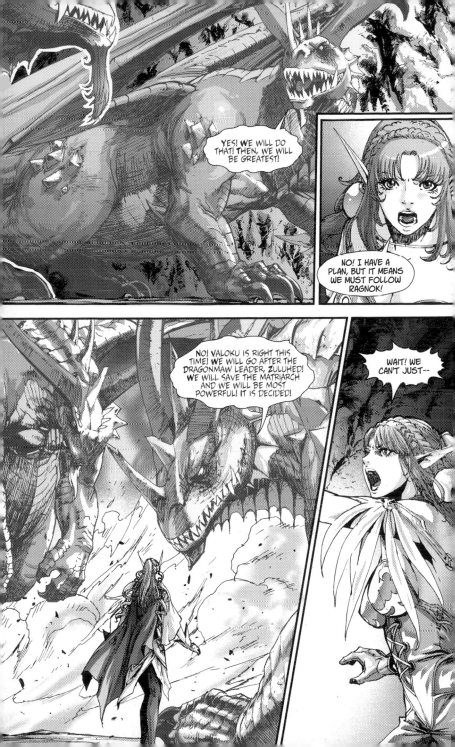

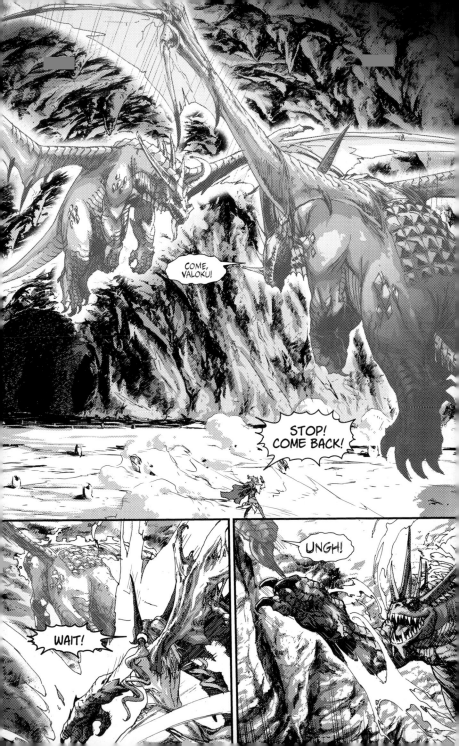

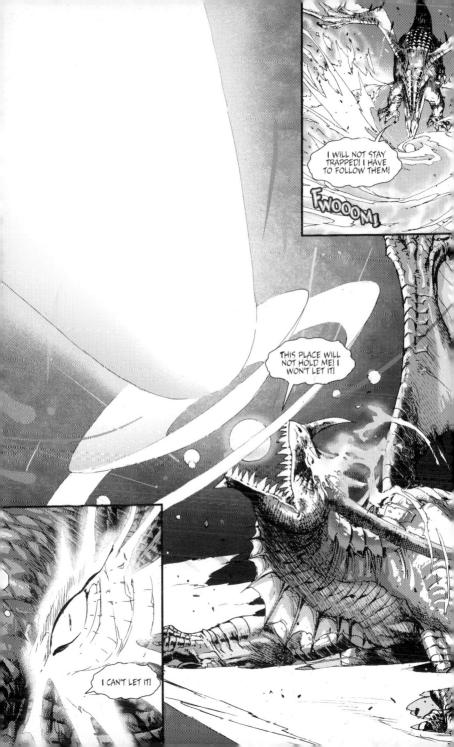

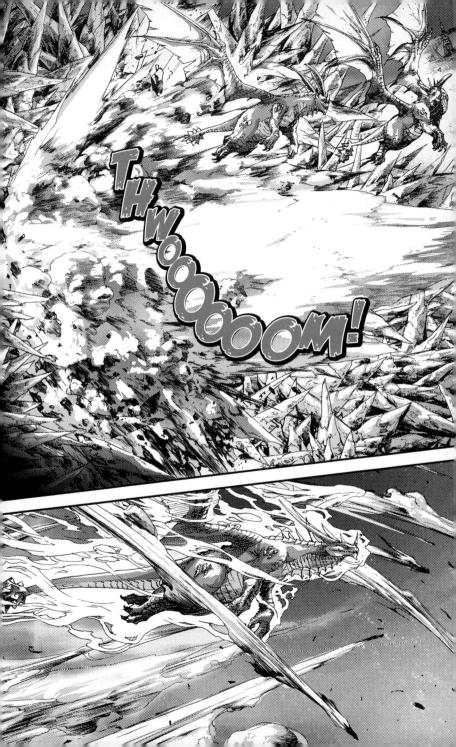

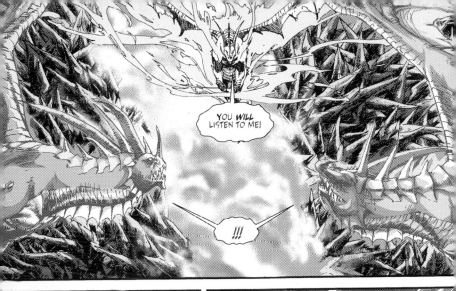

YOU *WILL* LISTEN TO ME!

!!!

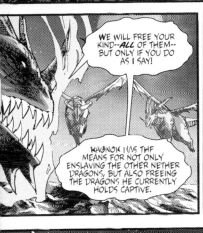

WE WILL FREE YOUR KIND--*ALL* OF THEM-- BUT ONLY IF YOU DO AS I SAY!

RAGNOK HAS THE MEANS FOR NOT ONLY ENSLAVING THE OTHER NETHER DRAGONS, BUT ALSO FREEING THE DRAGONS HE CURRENTLY HOLDS CAPTIVE.

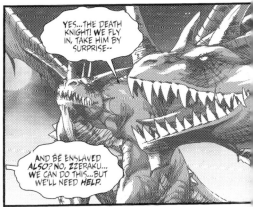

YES...THE DEATH KNIGHT! WE FLY IN, TAKE HIM BY SURPRISE--

AND BE ENSLAVED *ALSO?* NO, ZZERAKU... WE CAN DO THIS...BUT WE'LL NEED *HELP.*

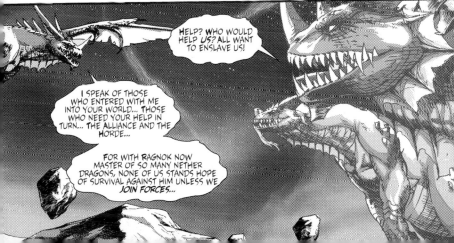

HELP? WHO WOULD HELP *US?* ALL WANT TO ENSLAVE US!

I SPEAK OF THOSE WHO ENTERED WITH ME INTO YOUR WORLD... THOSE WHO NEED YOUR HELP IN TURN... THE ALLIANCE AND THE HORDE...

FOR WITH RAGNOK NOW MASTER OF SO MANY NETHER DRAGONS, NONE OF US STANDS HOPE OF SURVIVAL AGAINST HIM UNLESS WE *JOIN FORCES...*

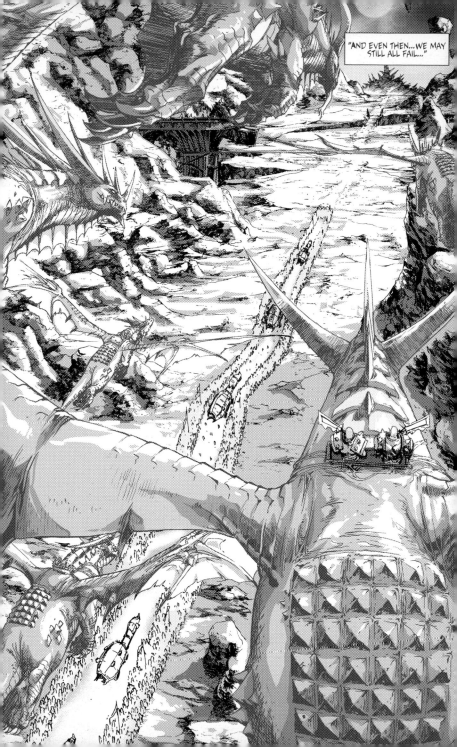

CHAPTER TWO
UPON DEAF EARS

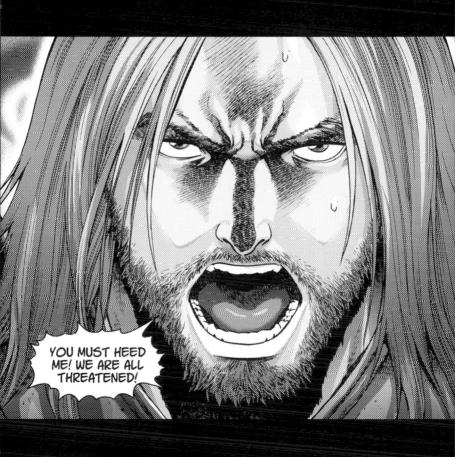

YOU MUST HEED ME! WE ARE ALL THREATENED!

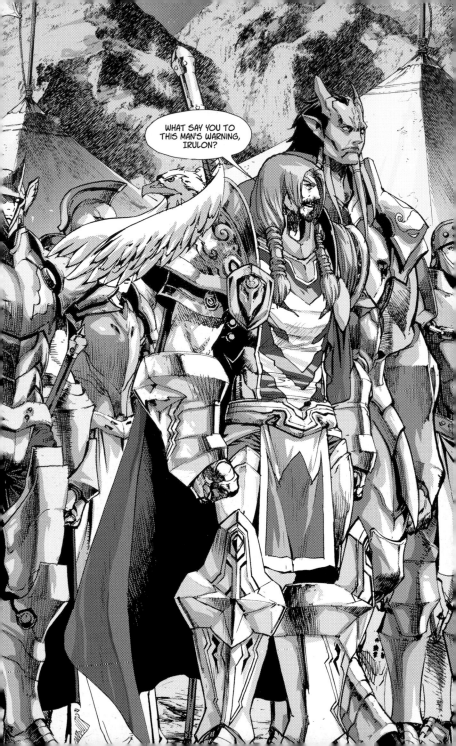

JORAD MACE IS NOT KNOWN TO ME AS ONE WHO SPEAKS FALSELY, BUT HIS MIND HAS BEEN DISTRAUGHT AND THERE IS MUCH IN HIS PAST HE NEEDS TO MAKE AMENDS FOR.

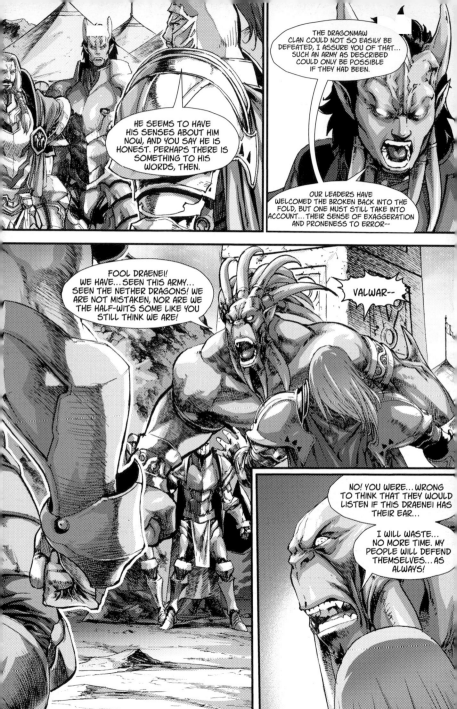

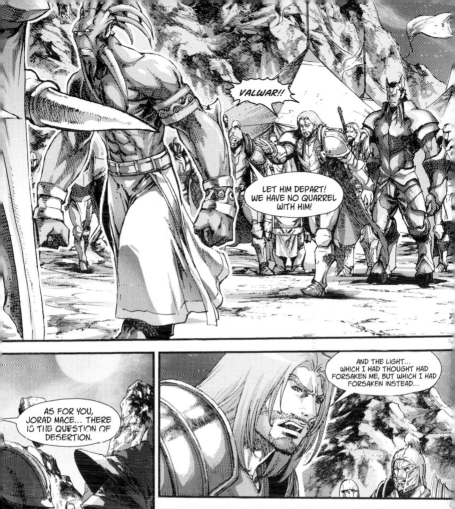

VALWAR!!

LET HIM DEPART! WE HAVE NO QUARREL WITH HIM!

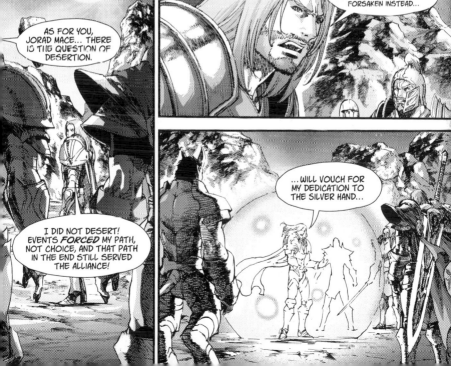

AS FOR YOU, JORAD MACE... THERE IS THE QUESTION OF DESERTION.

AND THE LIGHT... WHICH I HAD THOUGHT HAD FORSAKEN ME, BUT WHICH I HAD FORSAKEN INSTEAD...

I DID NOT DESERT! EVENTS FORCED MY PATH, NOT CHOICE, AND THAT PATH IN THE END STILL SERVED THE ALLIANCE!

...WILL VOUCH FOR MY DEDICATION TO THE SILVER HAND...

VALWAR! YOU ARE... BACK! WE FEARED FOR YOU WHILE YOU... WERE AMONG THE OUTSIDERS!

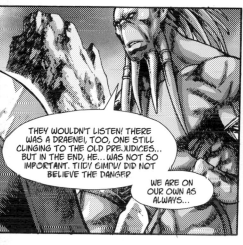

THEY WOULDN'T LISTEN! THERE WAS A DRAENEI, TOO, ONE STILL CLINGING TO THE OLD PREJUDICES... BUT IN THE END, HE... WAS NOT SO IMPORTANT. THEY SIMPLY DID NOT BELIEVE THE DANGER.

WE ARE ON OUR OWN AS ALWAYS...

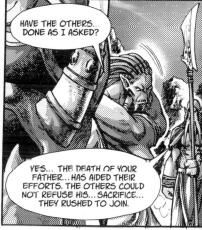

HAVE THE OTHERS... DONE AS I ASKED?

YES... THE DEATH OF YOUR FATHER... HAS AIDED THEIR EFFORTS. THE OTHERS COULD NOT REFUSE HIS... SACRIFICE... THEY RUSHED TO JOIN.

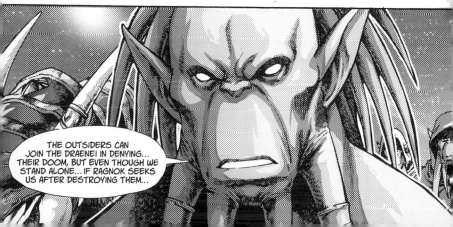

THE OUTSIDERS CAN JOIN THE DRAENEI IN DENYING... THEIR DOOM, BUT EVEN THOUGH WE STAND ALONE...IF RAGNOK SEEKS US AFTER DESTROYING THEM...

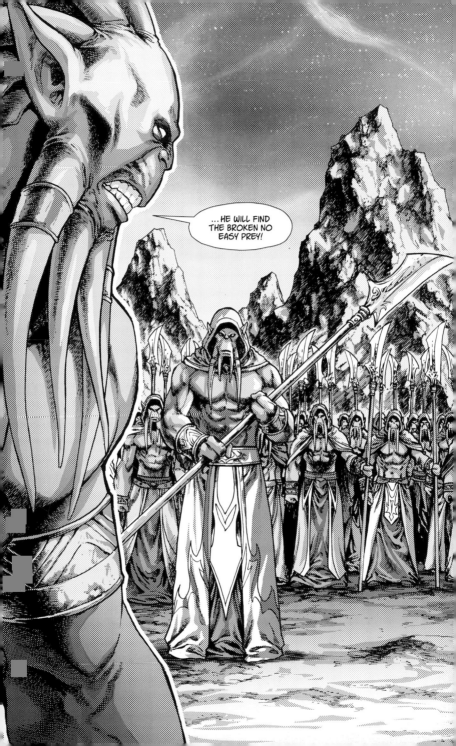

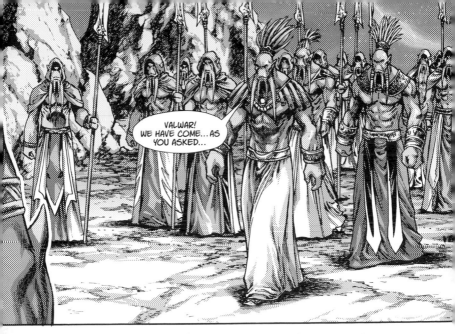

VALWAR!
WE HAVE COME... AS
YOU ASKED...

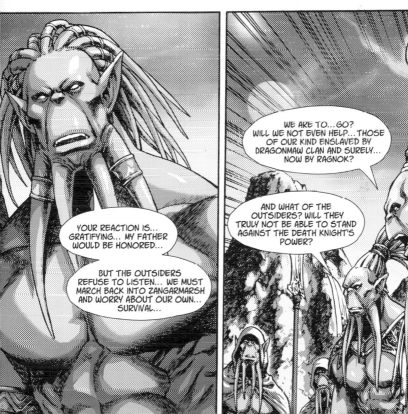

WE ARE TO... GO?
WILL WE NOT EVEN HELP... THOSE
OF OUR KIND ENSLAVED BY
DRAGONMAW CLAN AND SURELY...
NOW BY RAGNOK?

AND WHAT OF THE
OUTSIDERS? WILL THEY
TRULY NOT BE ABLE TO STAND
AGAINST THE DEATH KNIGHT'S
POWER?

YOUR REACTION IS...
GRATIFYING... MY FATHER
WOULD BE HONORED...

BUT THE OUTSIDERS
REFUSE TO LISTEN... WE MUST
MARCH BACK INTO ZANGARMARSH
AND WORRY ABOUT OUR OWN...
SURVIVAL...

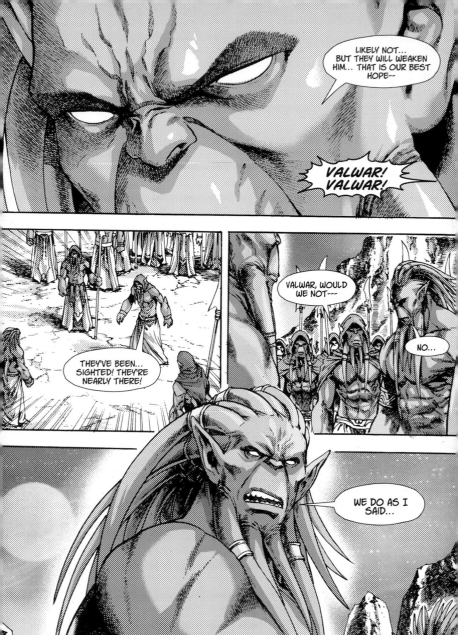

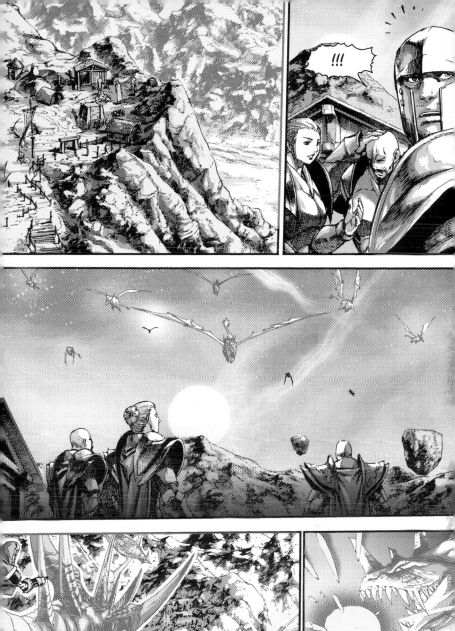

!!!

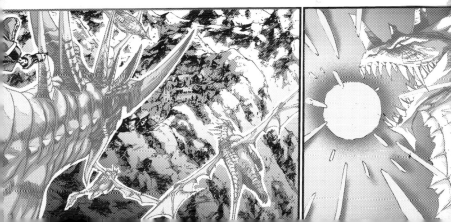

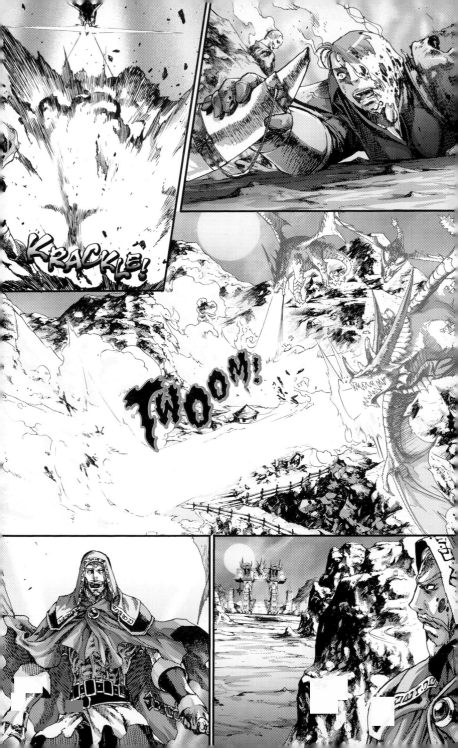

I LEAVE THIS MATTER IN YOUR HANDS, IRULON. YOU ARE THE BEST JUDGE OF THIS MAN OF YOURS.

I MAY HAVE BEEN TOO HASTY...

JORAD MACE HAS FOUND HIS WAY TO THE LIGHT AGAIN. THAT SPEAKS VOLUMES AS TO THE TRUST WE CAN PLACE IN HIM.

BUT HIS TALE...

IT MIGHT BE BEST IF YOU RAISE THE ALERT--

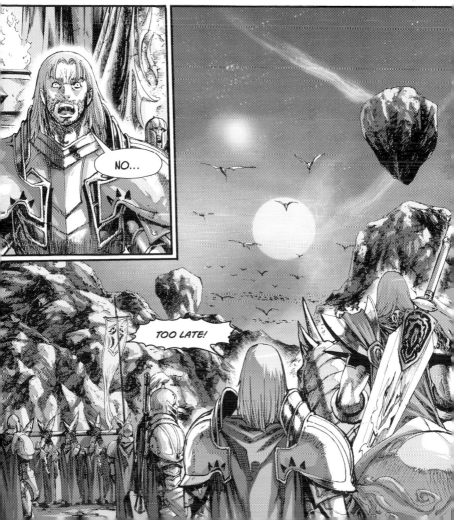

NO...

TOO LATE!

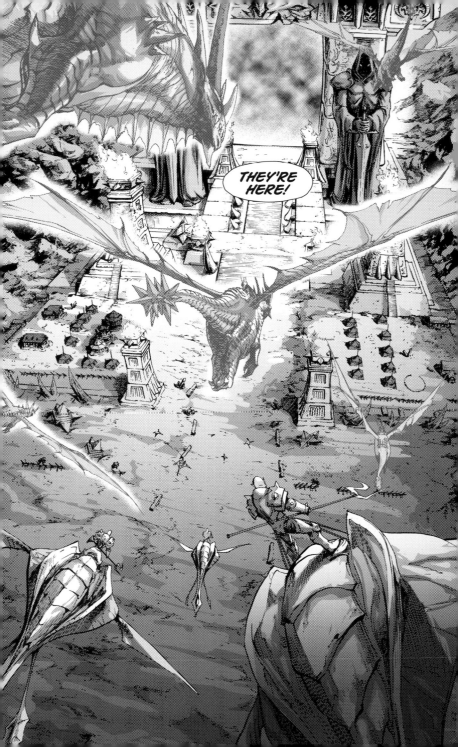

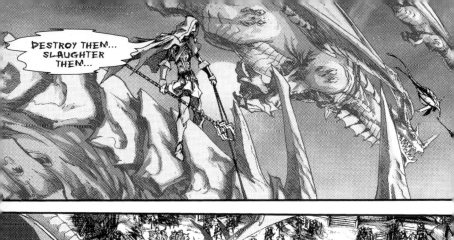

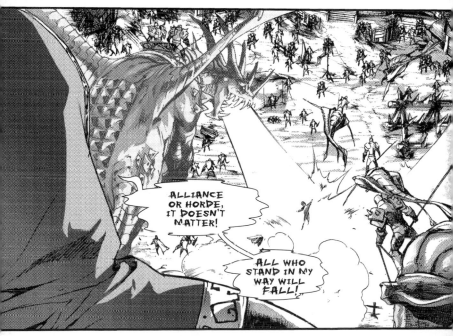

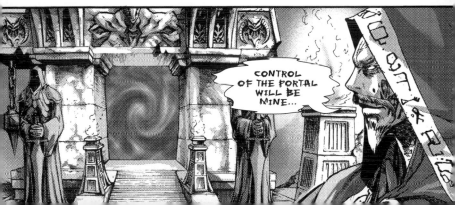

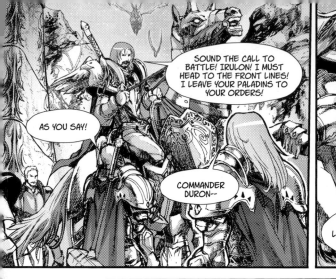

SOUND THE CALL TO BATTLE! IRULON! I MUST HEAD TO THE FRONT LINES! I LEAVE YOUR PALADINS TO YOUR ORDERS!

AS YOU SAY!

COMMANDER DURON--

THESE BEASTS ARE LIKE NONE OTHER! MERE WEAPONS WILL NOT--

DO NOT UNDER-ESTIMATE OUR WEAPONS... AND THE MAGI WITH US! WE SHALL BEAT BACK THESE FIENDS, PALADIN!

BUT--

DURON WILL SEE TO THE ALLIANCE AS A WHOLE, JORAD.

YOUR DUTY IS NOW TO STAND WITH YOUR BROTHERS... SOMEONE! GIVE HIM A *HAMMER!*

AYE, MY LORD!

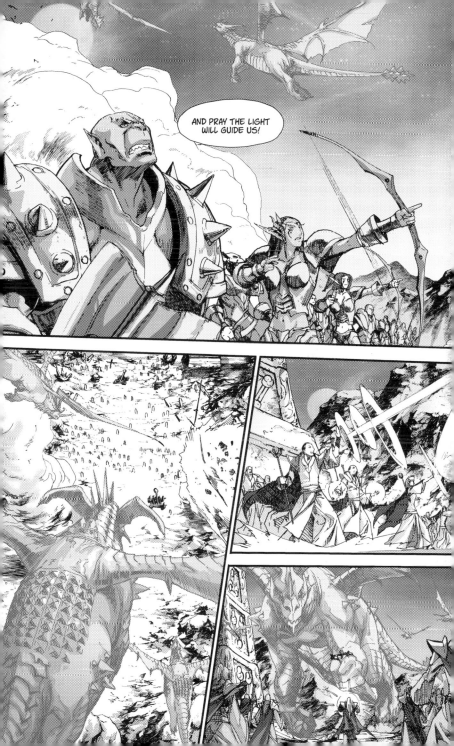

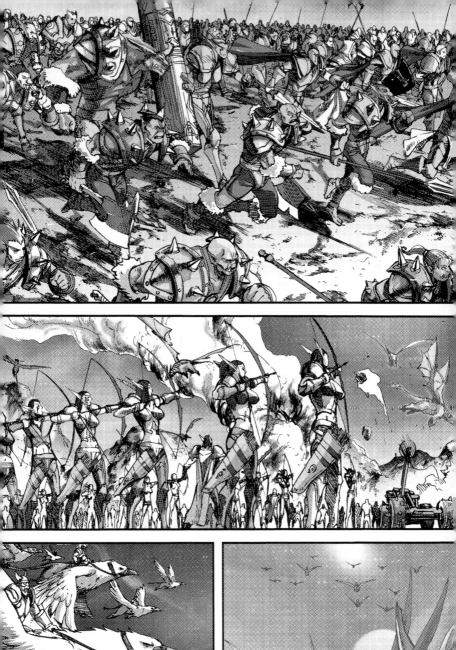

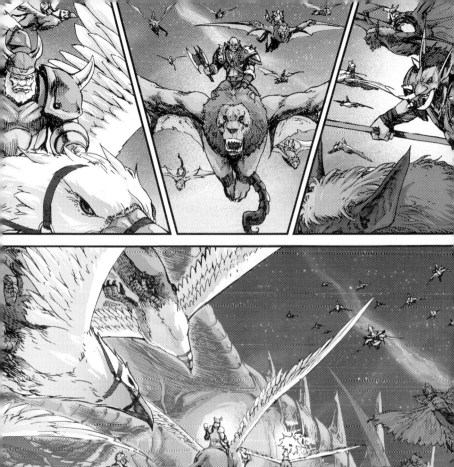

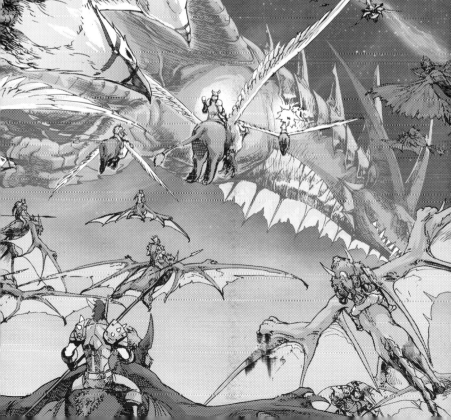

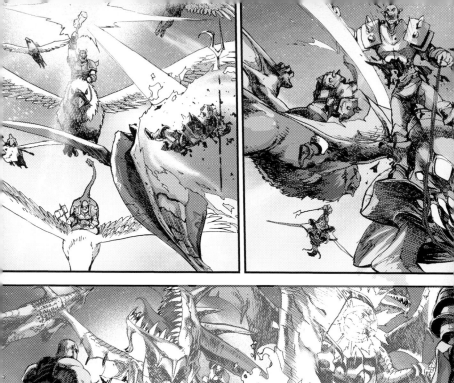

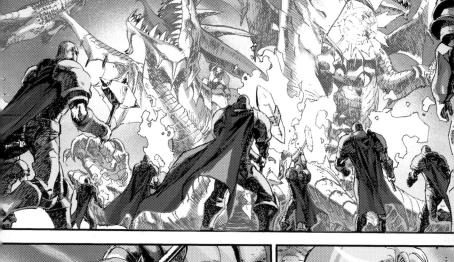

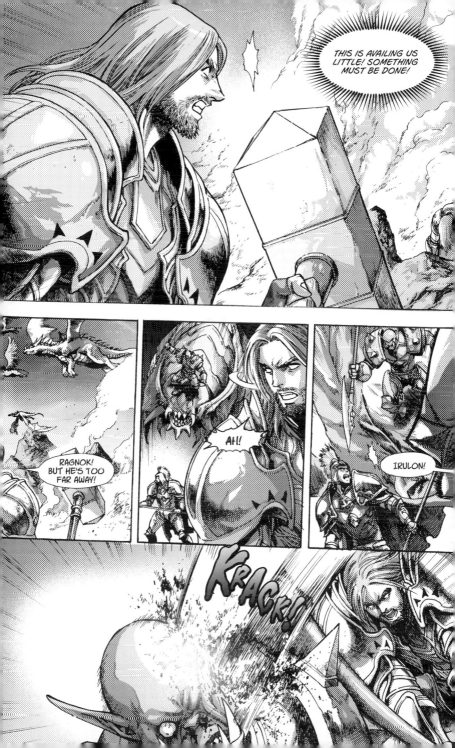

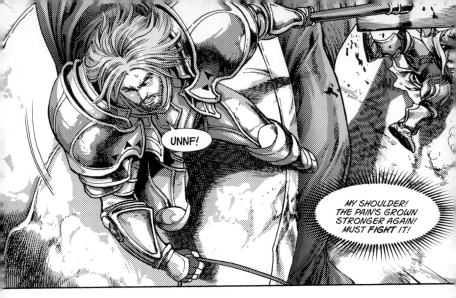

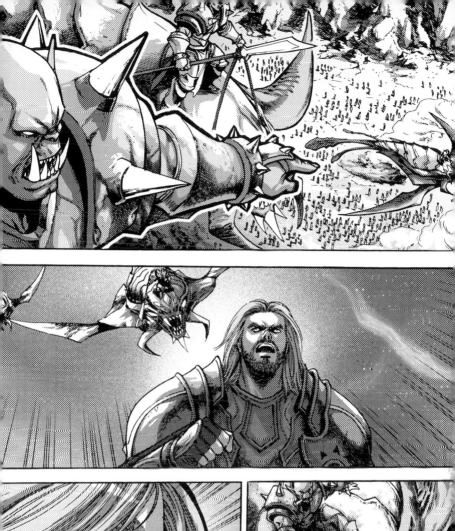

EH?

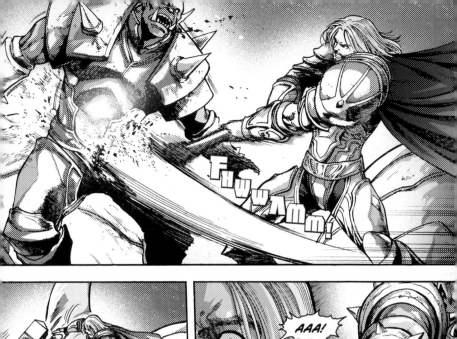

FHWWWMM!

YAAAAAA!

AAA!

!!!

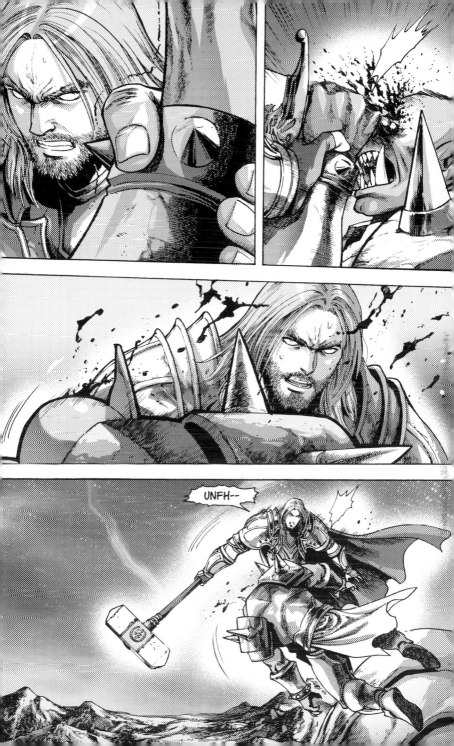

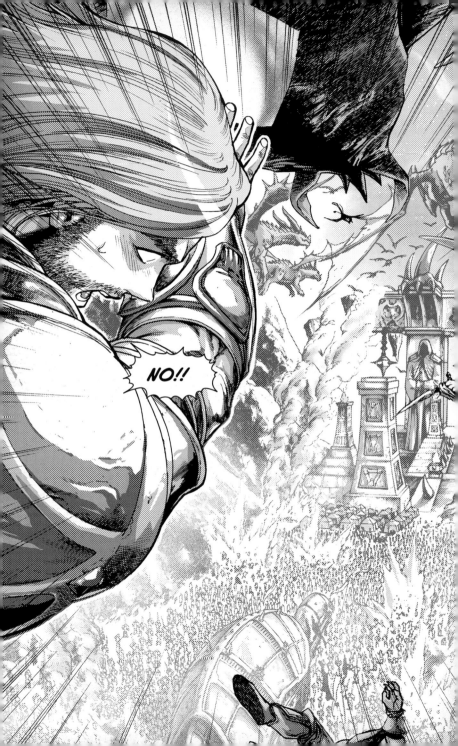

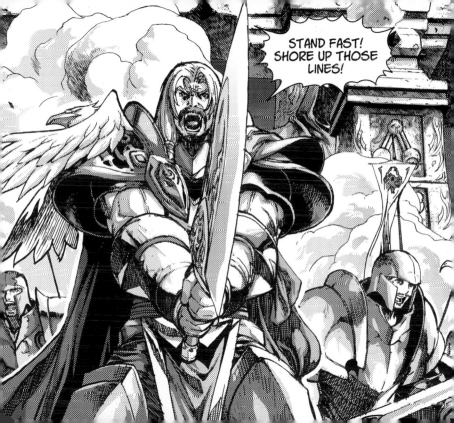

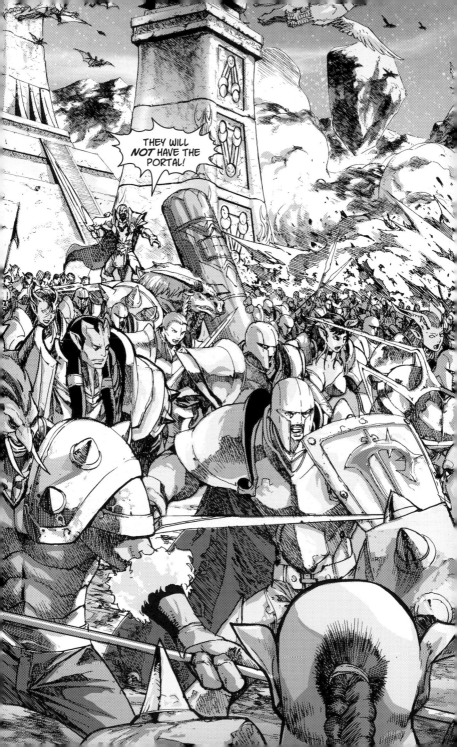

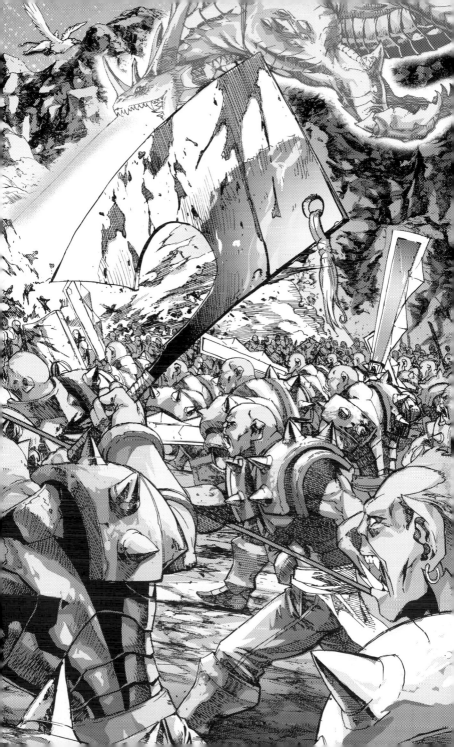

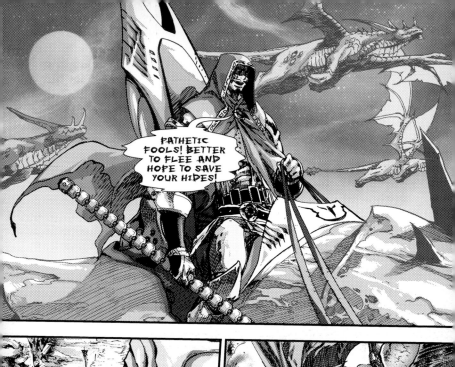

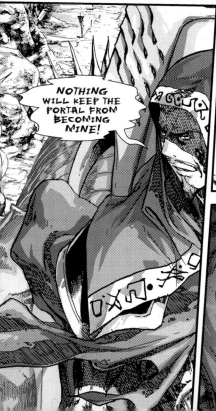

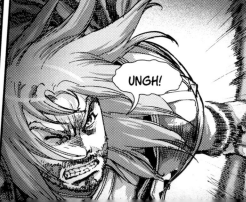

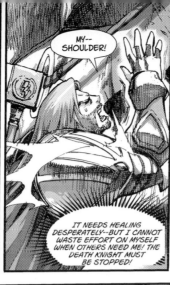

MY--
SHOULDER!

YES!

IT NEEDS HEALING DESPERATELY--BUT I CANNOT WASTE EFFORT ON MYSELF WHEN OTHERS NEED ME! THE DEATH KNIGHT MUST BE STOPPED!

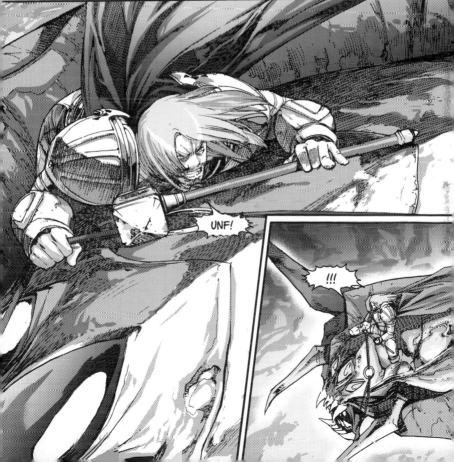

UNF!

!!!

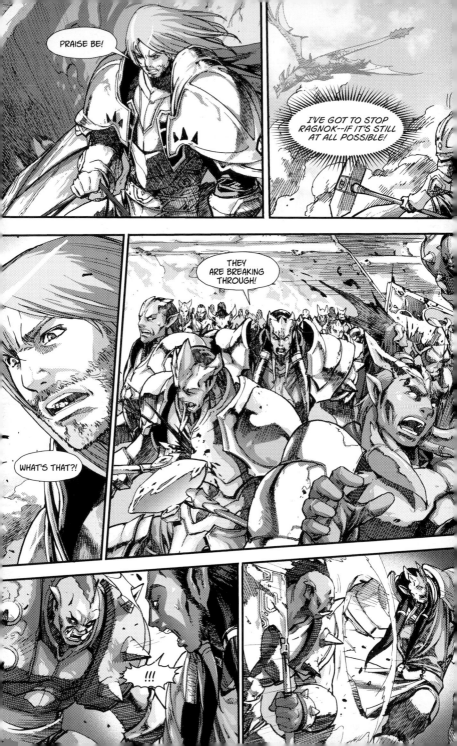

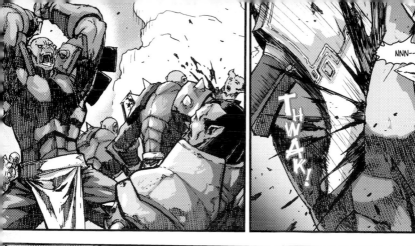

NNN--

THWAK!

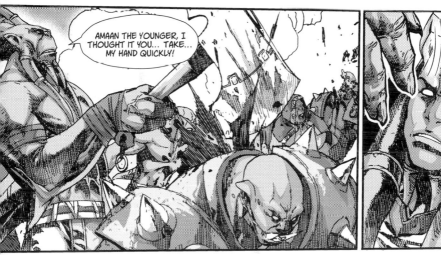

AMAAN THE YOUNGER, I THOUGHT IT YOU... TAKE... MY HAND QUICKLY!

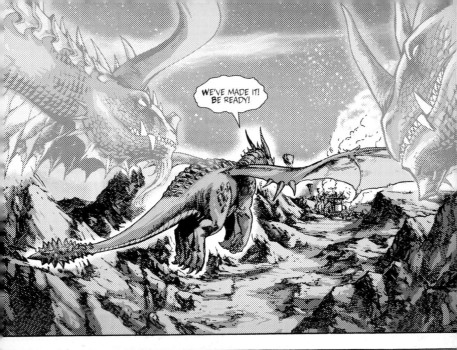

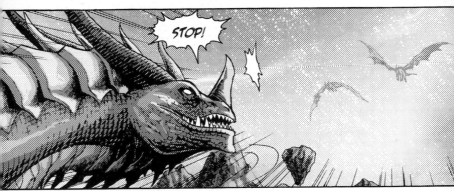

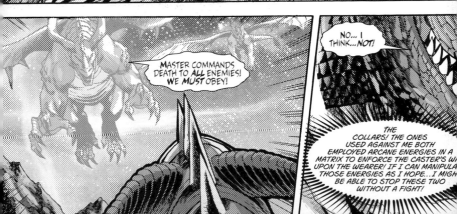

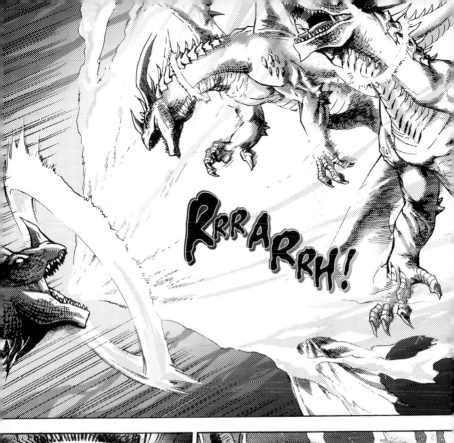

RRRARRH!

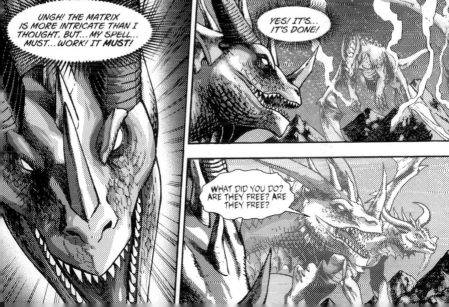

UNGH! THE MATRIX IS MORE INTRICATE THAN I THOUGHT, BUT...MY SPELL... MUST...WORK! IT **MUST!**

YES! IT'S... IT'S DONE!

WHAT DID YOU DO? ARE THEY FREE? ARE THEY FREE?

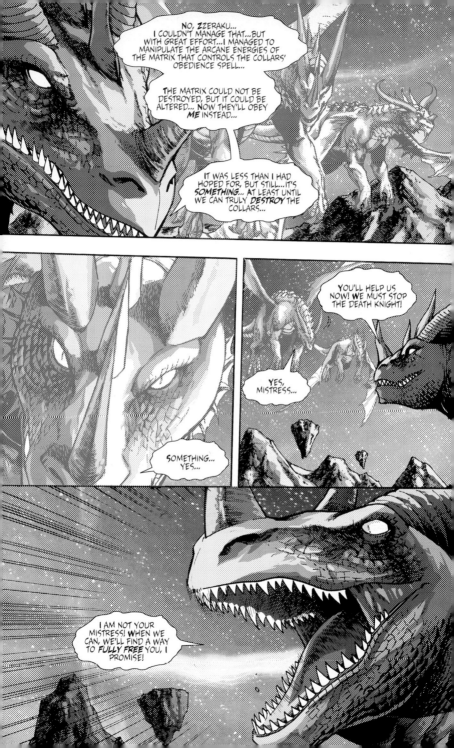

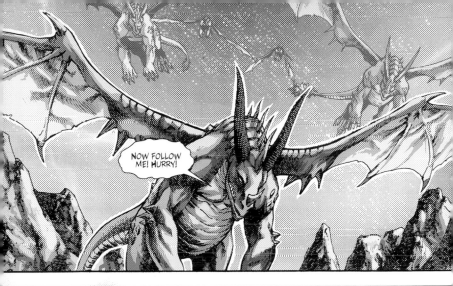

NOW FOLLOW ME! HURRY!

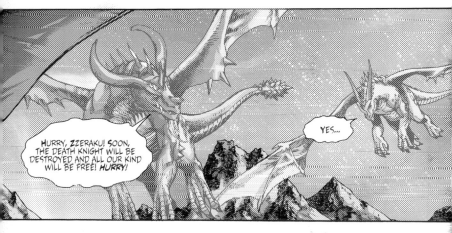

HURRY, ZZERAKU! SOON, THE DEATH KNIGHT WILL BE DESTROYED AND ALL OUR KIND WILL BE FREE! *HURRY!*

YES...

THEY WILL BE FREE...

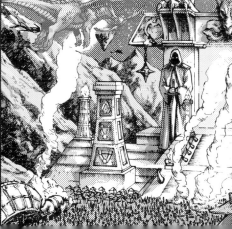

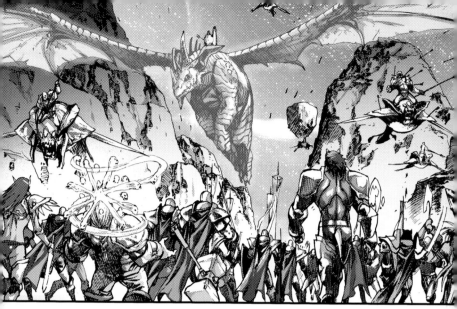

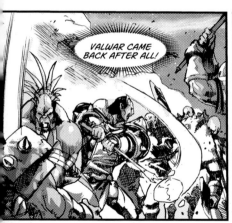

VALWAR CAME BACK AFTER ALL!

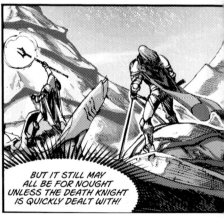

BUT IT STILL MAY ALL BE FOR NOUGHT UNLESS THE DEATH KNIGHT IS QUICKLY DEALT WITH!

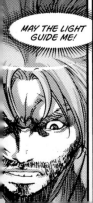

MAY THE LIGHT GUIDE ME!

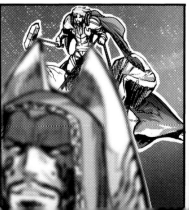

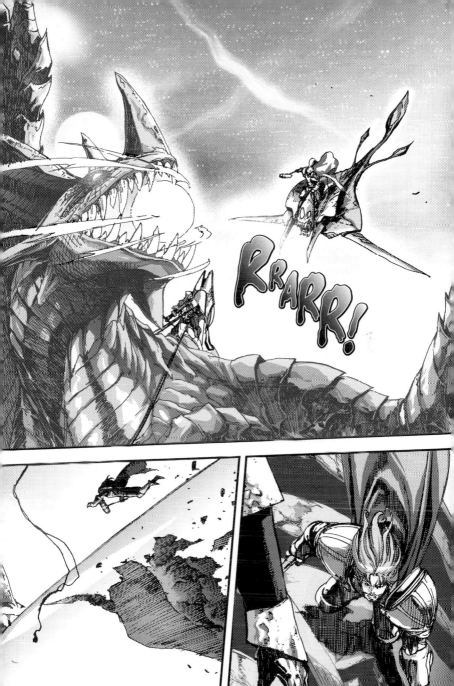

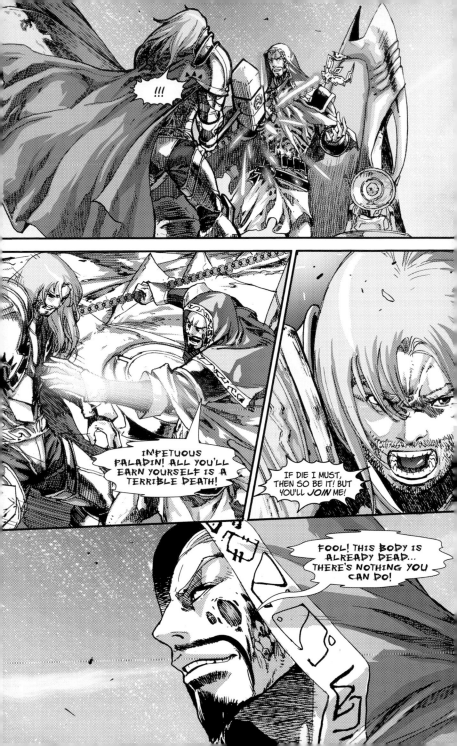

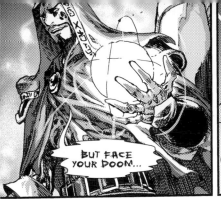

BUT FACE YOUR DOOM...

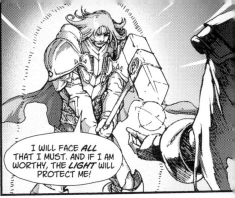

I WILL FACE *ALL* THAT I MUST. AND IF I AM WORTHY, THE *LIGHT* WILL PROTECT ME!

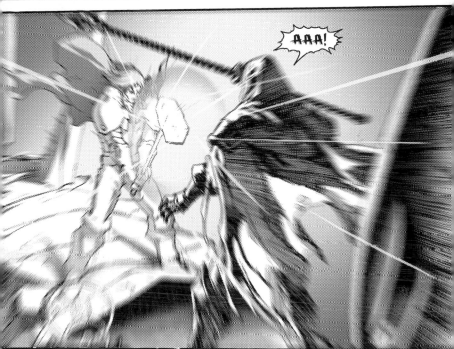

AAA!

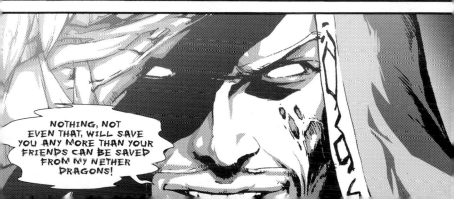

NOTHING, NOT EVEN THAT, WILL SAVE YOU ANY MORE THAN YOUR FRIENDS CAN BE SAVED FROM MY NETHER DRAGONS!

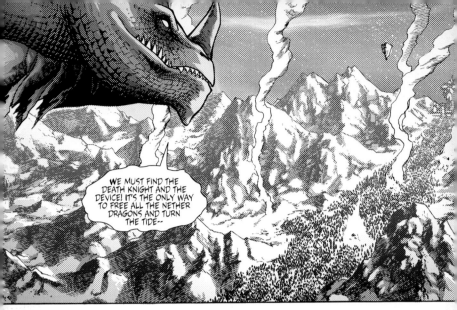

WE MUST FIND THE DEATH KNIGHT AND THE DEVICE! IT'S THE ONLY WAY TO FREE ALL THE NETHER DRAGONS AND TURN THE TIDE--

THERE! RAGNOK-- AND *JORAD?!*

FRIEND *TYRI!* MORE OF OUR BROTHERS AND SISTERS!

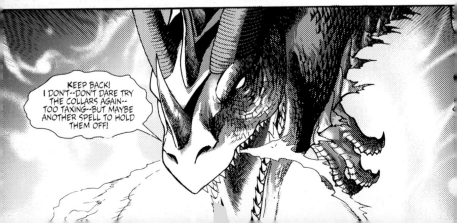

KEEP BACK! I DON'T--DON'T DARE TRY THE COLLARS AGAIN-- TOO TAXING--BUT MAYBE ANOTHER SPELL TO HOLD THEM OFF!

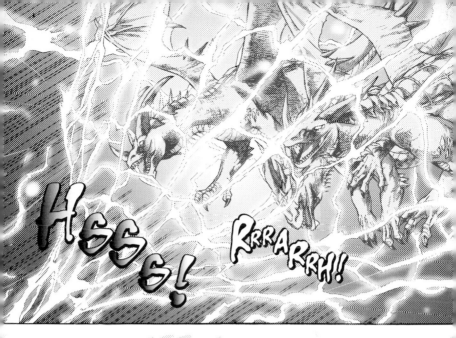

HSSS!

RRRARRH!

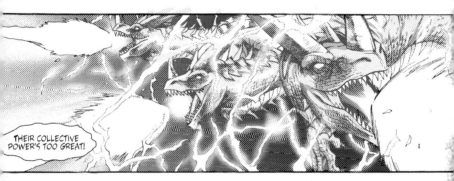

THEIR COLLECTIVE POWER'S TOO GREAT!

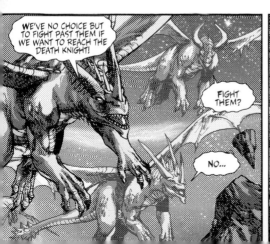

WE'VE NO CHOICE BUT TO FIGHT PAST THEM IF WE WANT TO REACH THE DEATH KNIGHT!

FIGHT THEM?

NO...

DO AS I SAY! IT'S OUR ONLY HOPE!

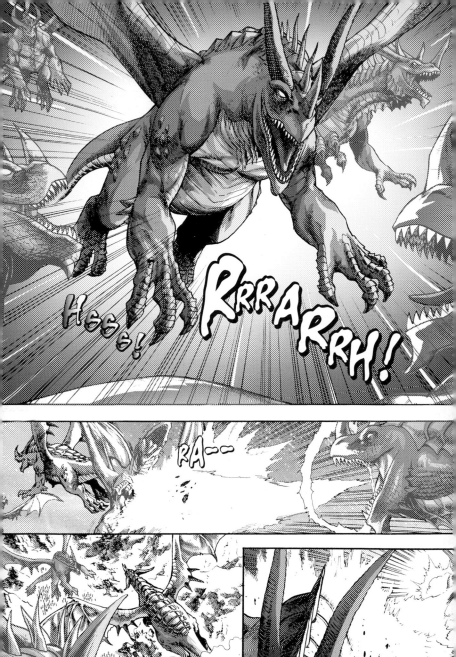
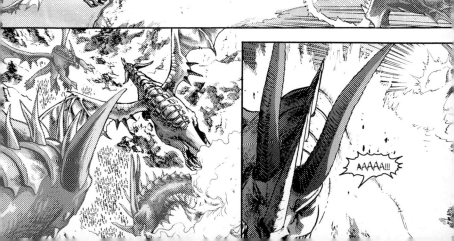

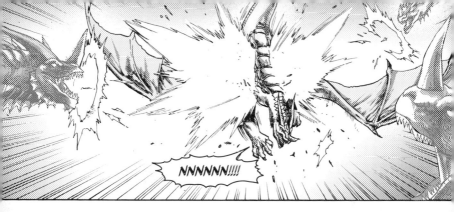

NNNNNN!!!!

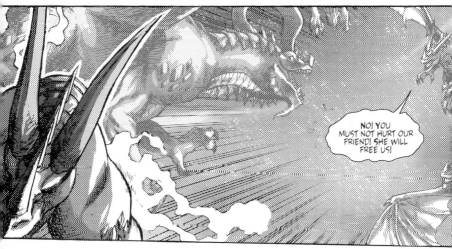

NO! YOU MUST NOT HURT OUR FRIEND! SHE WILL FREE US!

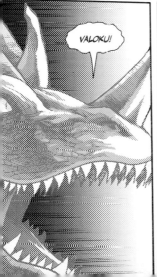

VALOKU!

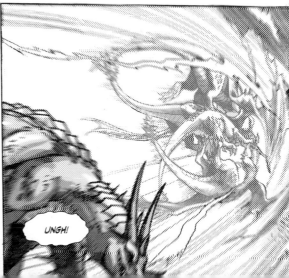

UNGH!

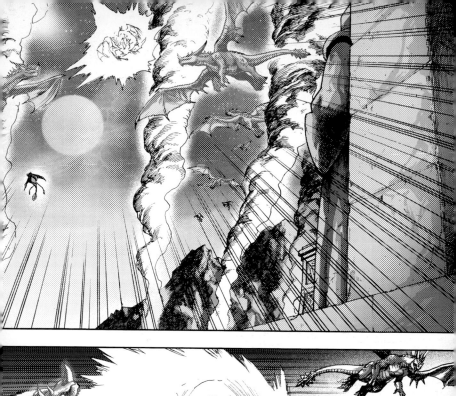

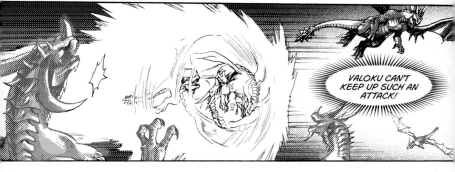

VALOKU CAN'T KEEP UP SUCH AN ATTACK!

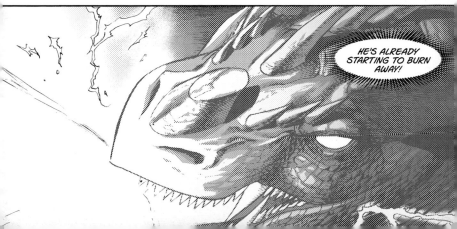

HE'S ALREADY STARTING TO BURN AWAY!

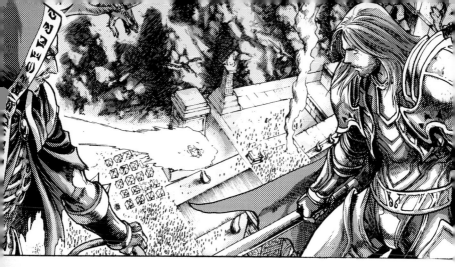

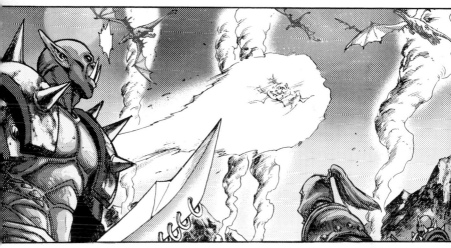

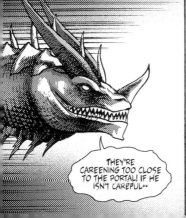

THEY'RE CAREENING TOO CLOSE TO THE PORTAL! IF HE ISN'T CAREFUL--

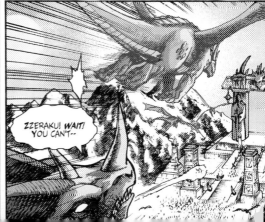

ZZERAKU! *WAIT!* YOU CAN'T--

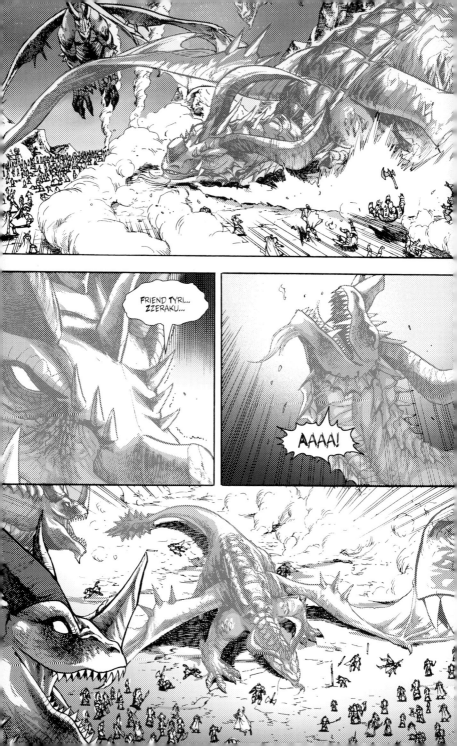

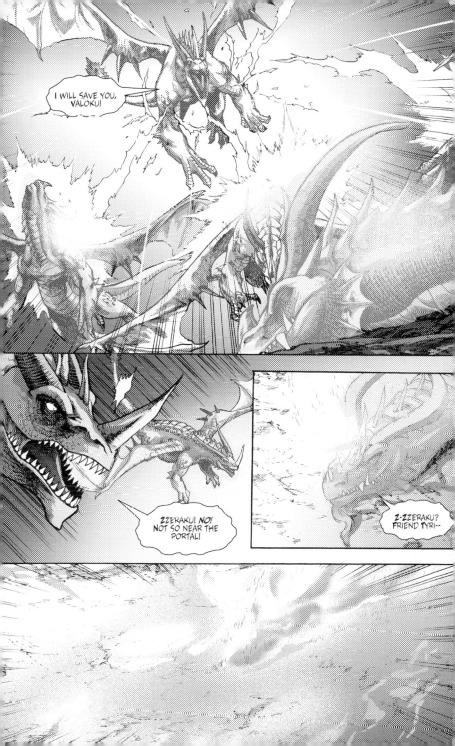

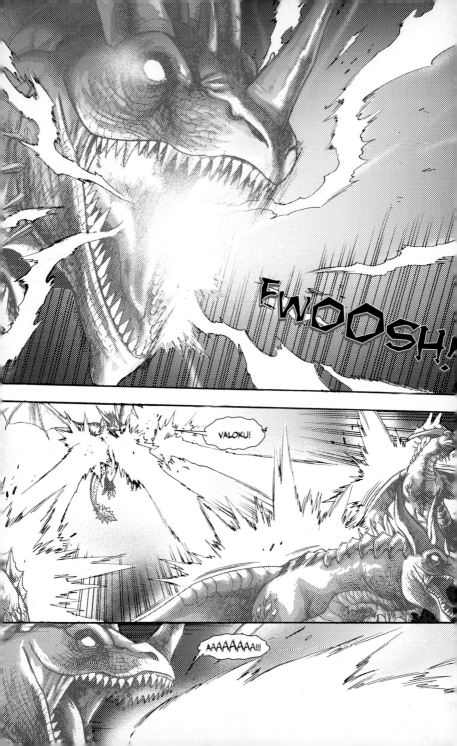

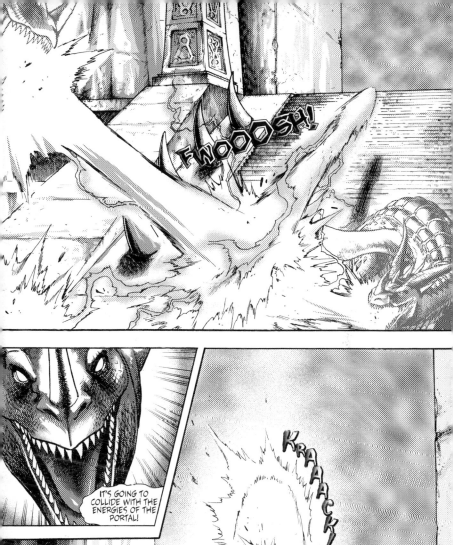

FWOOOSH!

IT'S GOING TO COLLIDE WITH THE ENERGIES OF THE PORTAL!

KRAAACKLE!

THWOOM!

KRACKLE!

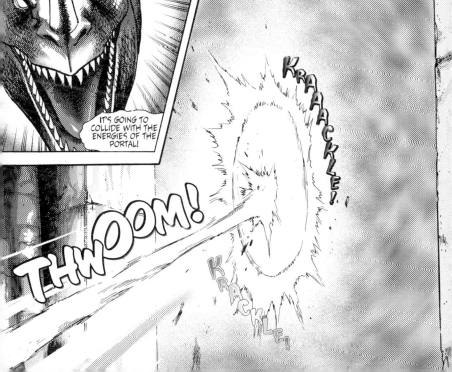

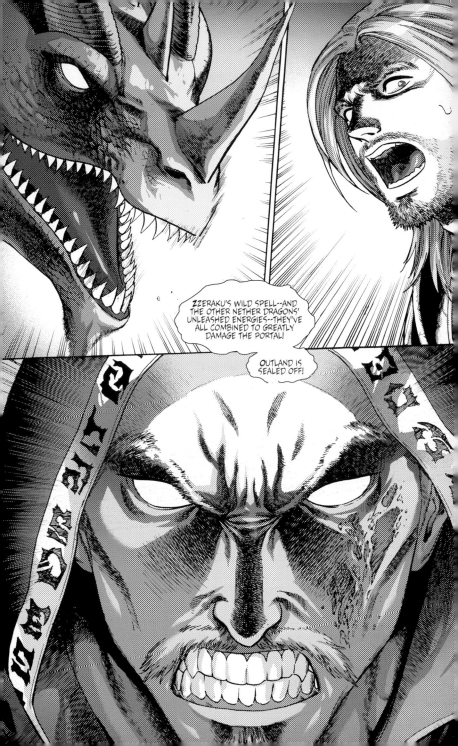

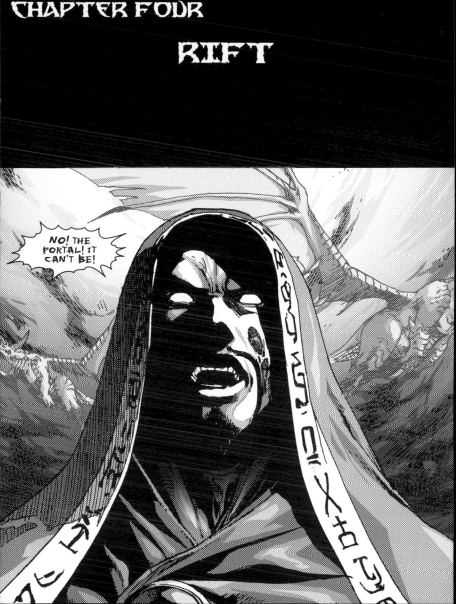

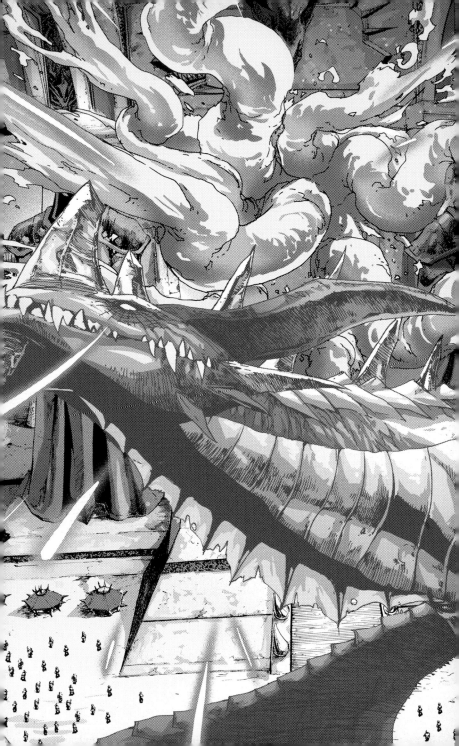

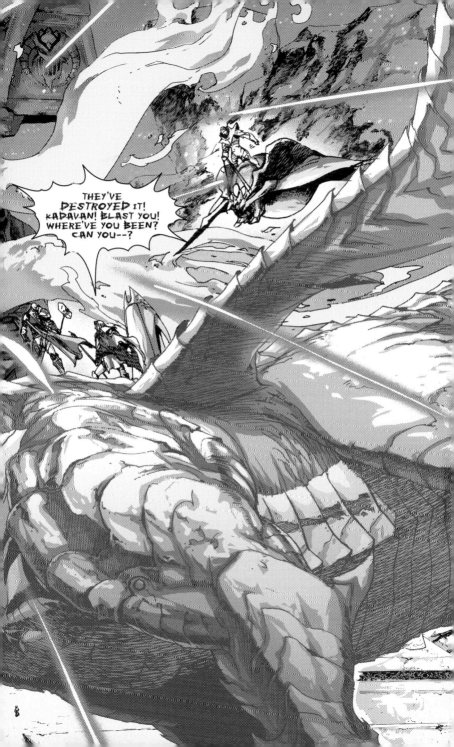

ENSURING THAT ALL THE COLLARS REMAIN FUNCTIONING AT THEIR OPTIMUM, AS PER OUR CONTRACT AND YOUR REQUEST... I GUARANTEE ALL MY WARES, AS YOU KNOW...

BUT, UNFORTUNATELY, WHILE A METHOD OF ENSNARING NETHER DRAGONS IS ONE THING... REVIVING A PORTAL... NOW *THAT* WOULD BE A PROFITABLE DEVICE, IF I HAD ONE.

CURSED DRAGON! SHE'LL *PAY!*

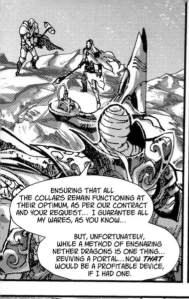

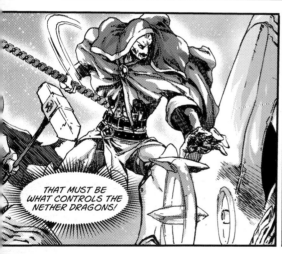

THAT MUST BE WHAT CONTROLS THE NETHER DRAGONS!

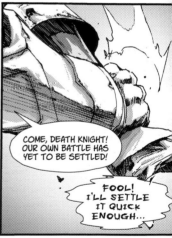

COME, DEATH KNIGHT! OUR OWN BATTLE HAS YET TO BE SETTLED!

FOOL! I'LL SETTLE IT QUICK ENOUGH...

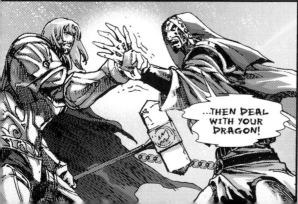

...THEN DEAL WITH YOUR DRAGON!

ALAS, IT SEEMS THIS VENTURE'S REACHED THE END OF ITS PROFITABILITY...

BEST TO TURN TO OTHER, MORE VALUABLE ENDEAVORS...

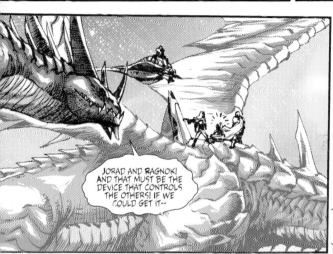

JORAD AND RAGNOK! AND THAT MUST BE THE DEVICE THAT CONTROLS THE OTHERS! IF WE COULD GET IT--

WHAT STRANGE EMANATIONS! I CAN FEEL THEM FROM HERE! IT CAN'T BE RAGNOK'S CREATION! HE MUST'VE OBTAINED IT FROM SOMEONE ELSE--

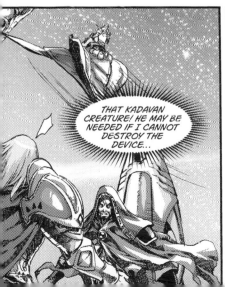

THAT KADAVAN CREATURE! HE MAY BE NEEDED IF I CANNOT DESTROY THE DEVICE...

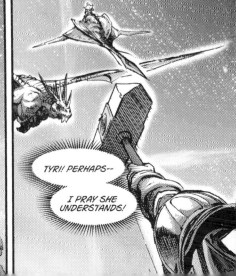

TYRI! PERHAPS--

I PRAY SHE UNDERSTANDS!

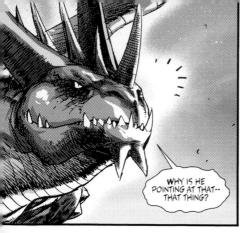

WHY IS HE POINTING AT THAT-- THAT THING?

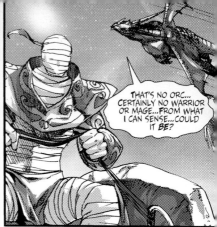

THAT'S NO ORC... CERTAINLY NO WARRIOR OR MAGE...FROM WHAT I CAN SENSE...COULD IT *BE?*

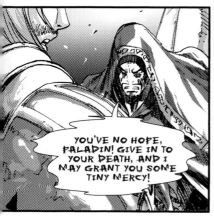

YOU'VE NO HOPE, PALADIN! GIVE IN TO YOUR DEATH, AND I MAY GRANT YOU SOME TINY MERCY!

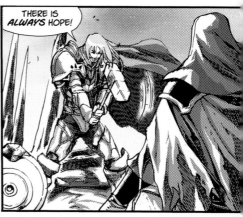

THERE IS *ALWAYS* HOPE!

THERE IS ALWAYS *THE LIGHT!*

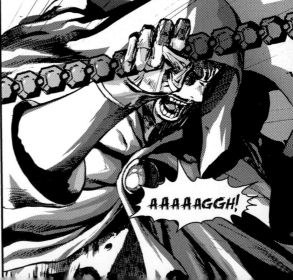

AAAAAGGH!

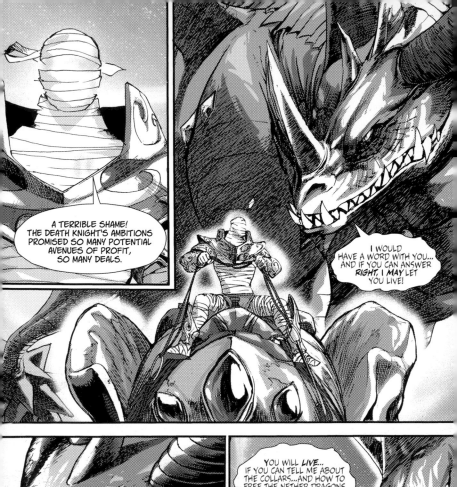

A TERRIBLE SHAME! THE DEATH KNIGHT'S AMBITIONS PROMISED SO MANY POTENTIAL AVENUES OF PROFIT, SO MANY DEALS.

I WOULD HAVE A WORD WITH YOU... AND IF YOU CAN ANSWER *RIGHT*, I *MAY* LET YOU LIVE!

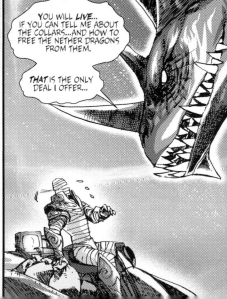

YOU WILL *LIVE*... IF YOU CAN TELL ME ABOUT THE COLLARS...AND HOW TO FREE THE NETHER DRAGONS FROM THEM.

THAT IS THE ONLY DEAL I OFFER...

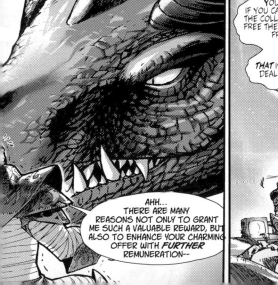

AHH... THERE ARE MANY REASONS NOT ONLY TO GRANT ME SUCH A VALUABLE REWARD, BUT ALSO TO ENHANCE YOUR CHARMING OFFER WITH *FURTHER* REMUNERATION--

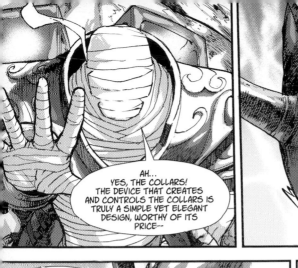

AH...
YES, THE COLLARS!
THE DEVICE THAT CREATES
AND CONTROLS THE COLLARS IS
TRULY A SIMPLE YET ELEGANT
DESIGN, WORTHY OF ITS
PRICE--

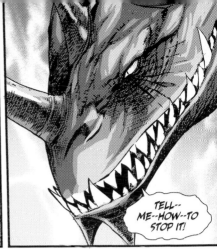

TELL--
ME--HOW--TO
STOP IT!

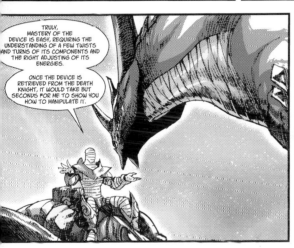

TRULY,
MASTERY OF THE
DEVICE IS EASY, REQUIRING THE
UNDERSTANDING OF A FEW TWISTS
AND TURNS OF ITS COMPONENTS AND
THE RIGHT ADJUSTING OF ITS
ENERGIES.

ONCE THE DEVICE IS
RETRIEVED FROM THE DEATH
KNIGHT, IT WOULD TAKE BUT
SECONDS FOR ME TO SHOW YOU
HOW TO MANIPULATE IT.

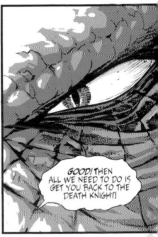

GOOD! THEN
ALL WE NEED TO DO IS
GET YOU BACK TO THE
DEATH KNIGHT!

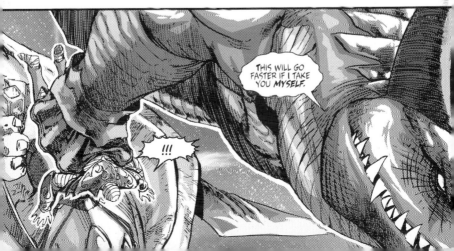

THIS WILL GO
FASTER IF I TAKE
YOU MYSELF.

!!!

UNNNF!!

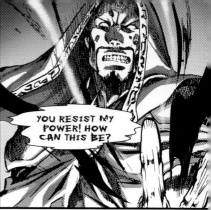

YOU RESIST MY POWER! HOW CAN THIS BE?

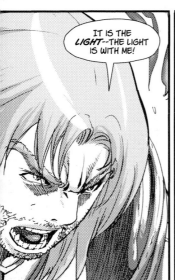

IT IS THE *LIGHT*--THE LIGHT IS WITH ME!

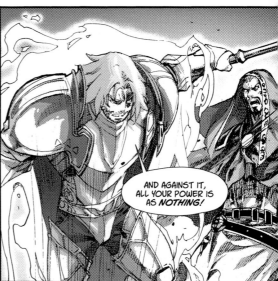

AND AGAINST IT, ALL YOUR POWER IS *NOTHING!*

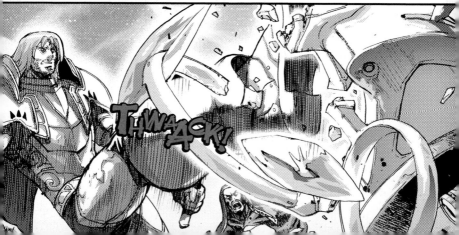

THWAACK!

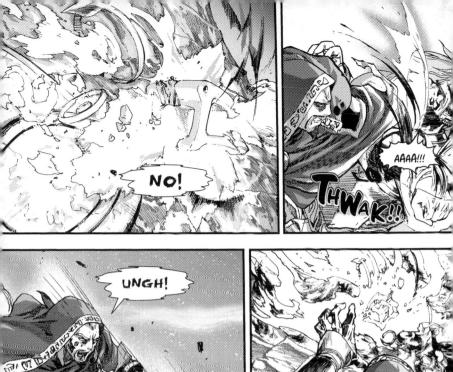

NO!

AAAA!!!

THWAK!!

UNGH!

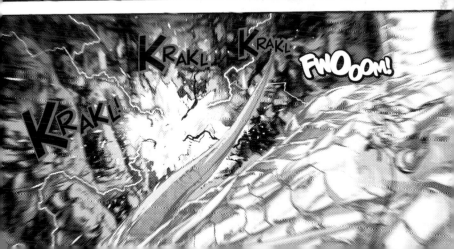

KRAKL!

KRAKL!

FWOOOM!

KRAKL!

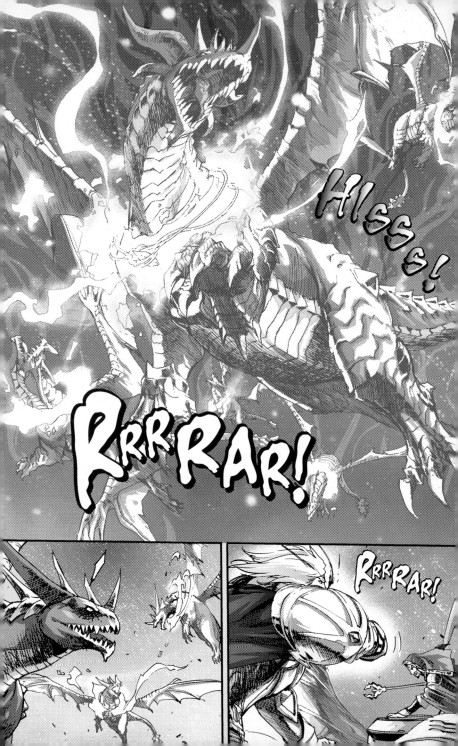

WHAT IS IT? WHAT'S HAPPENING?

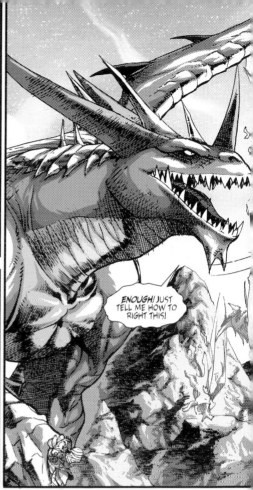

ENOUGH! JUST TELL ME HOW TO RIGHT THIS!

SOMETHING MUST HAVE DESTROYED THE DEVICE! I ALWAYS ADVISE THE CLIENT ABOUT PROPER HANDLING, BUT--

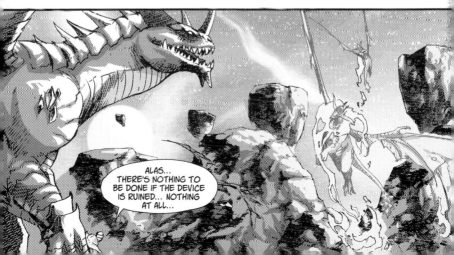

ALAS... THERE'S NOTHING TO BE DONE IF THE DEVICE IS RUINED... NOTHING AT ALL...

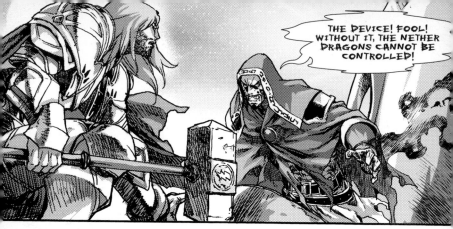

THE DEVICE! FOOL! WITHOUT IT, THE NETHER DRAGONS CANNOT BE CONTROLLED!

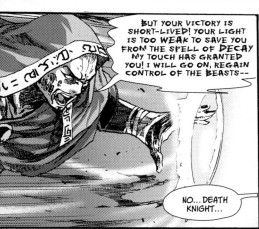

BUT YOUR VICTORY IS SHORT-LIVED! YOUR LIGHT IS TOO WEAK TO SAVE YOU FROM THE SPELL OF DECAY MY TOUCH HAS GRANTED YOU! I WILL GO ON, REGAIN CONTROL OF THE BEASTS--

NO... DEATH KNIGHT...

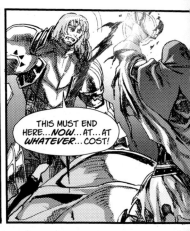

THIS MUST END HERE...NOW...AT...AT WHATEVER...COST!

YOUR WILL IS TOO WEAK! YOUR HOLY TRICKS WILL AVAIL YOU NOTHING THIS TIME, AND WITHOUT THEM, YOU ARE NOTHING!

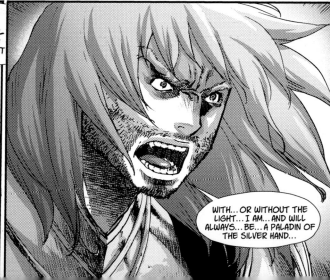

WITH... OR WITHOUT THE LIGHT... I AM... AND WILL ALWAYS... BE... A PALADIN OF THE SILVER HAND...

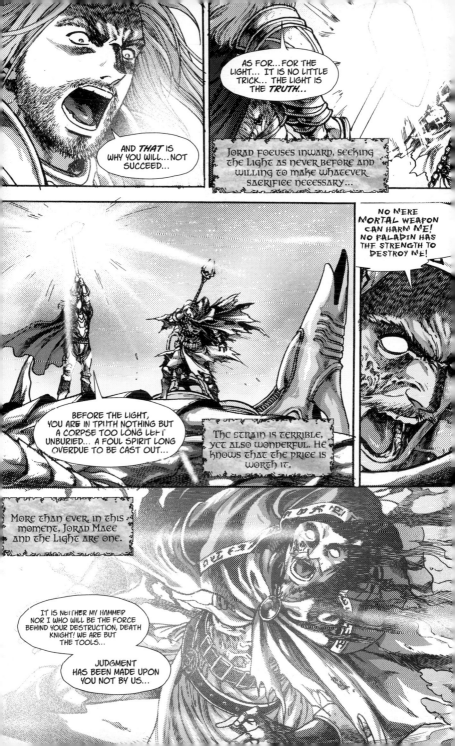

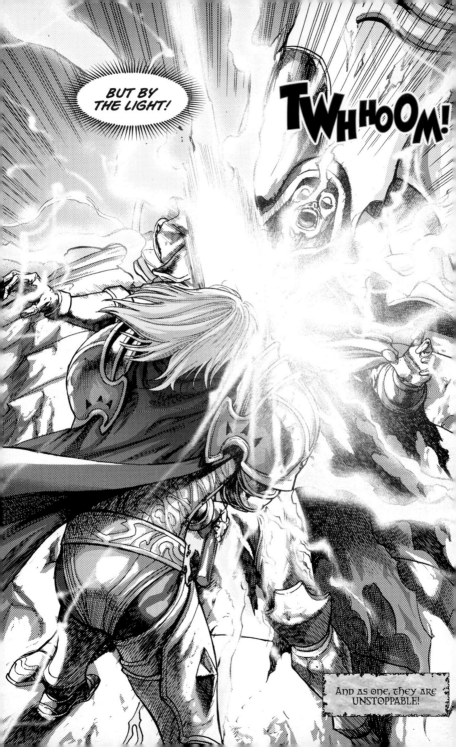

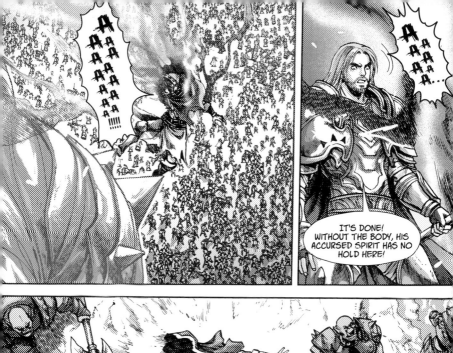

IT'S DONE! WITHOUT THE BODY, HIS ACCURSED SPIRIT HAS NO HOLD HERE!

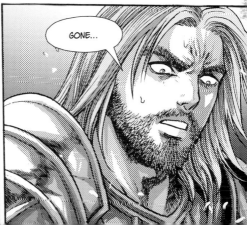

GONE...

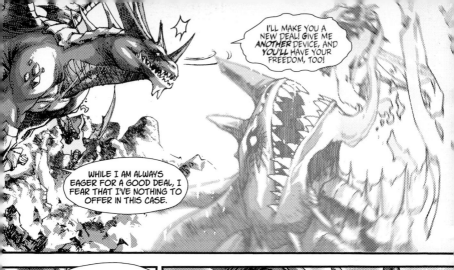

I'LL MAKE YOU A NEW DEAL! GIVE ME *ANOTHER* DEVICE, AND *YOU'LL* HAVE YOUR FREEDOM, TOO!

WHILE I AM ALWAYS EAGER FOR A GOOD DEAL, I FEAR THAT I'VE NOTHING TO OFFER IN THIS CASE.

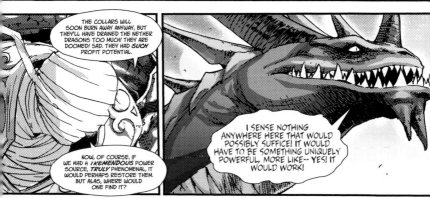

THE COLLARS WILL SOON BURN AWAY ANYWAY, BUT THEY'LL HAVE DRAINED THE NETHER DRAGONS TOO MUCH! THEY ARE DOOMED! SAD. THEY HAD *SUCH* PROFIT POTENTIAL.

NOW, OF COURSE, IF WE HAD A *TREMENDOUS* POWER SOURCE, *TRULY* PHENOMENAL, IT WOULD PERHAPS RESTORE THEM. BUT ALAS, WHERE WOULD ONE FIND IT?

I SENSE NOTHING ANYWHERE HERE THAT WOULD POSSIBLY SUFFICE! IT WOULD HAVE TO BE SOMETHING UNIQUELY POWERFUL, MORE LIKE-- YES! IT WOULD WORK!

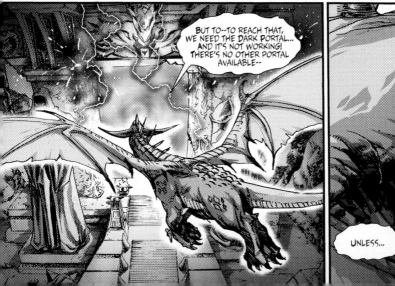

BUT TO--TO REACH THAT, WE NEED THE DARK PORTAL... AND IT'S NOT WORKING! THERE'S NO OTHER PORTAL AVAILABLE--

UNLESS...

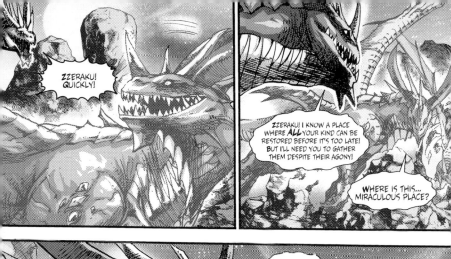

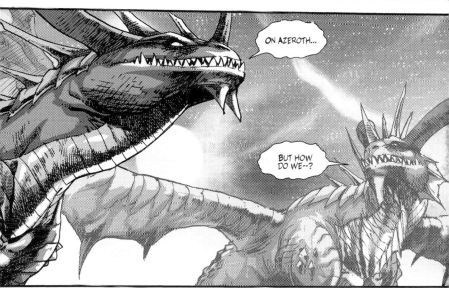

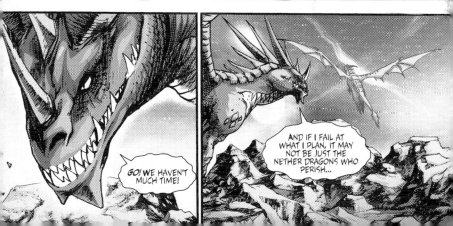

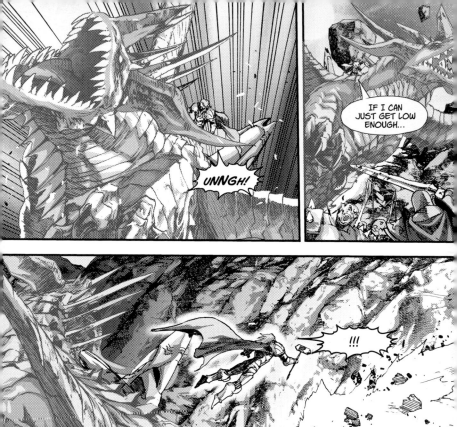

UNNGH!

IF I CAN JUST GET LOW ENOUGH...

!!!

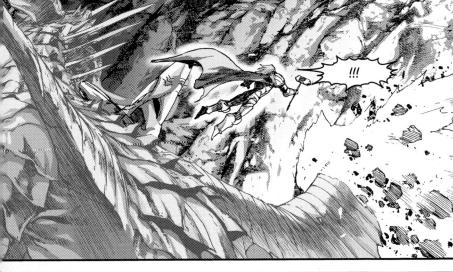

UNF!

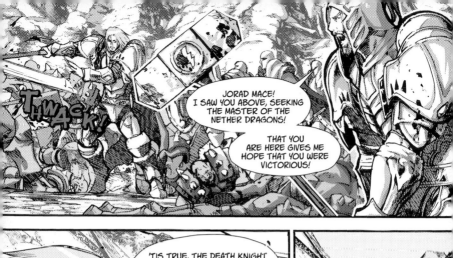

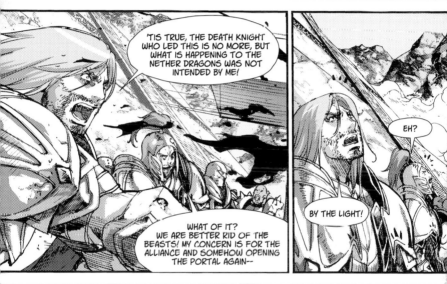

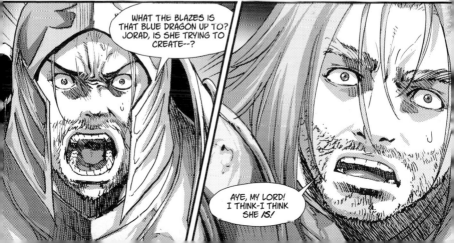

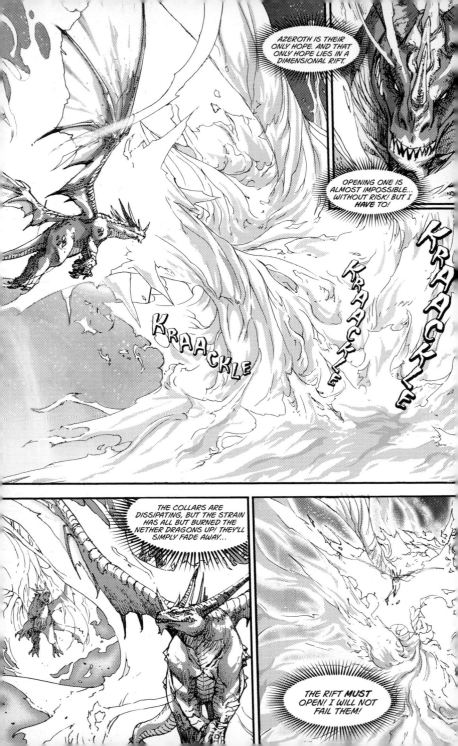

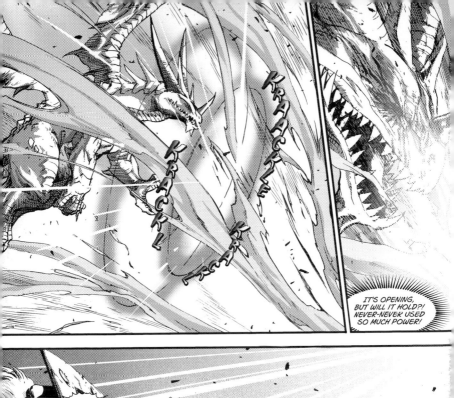

KRAACKLE

KRAACK!

KRAAACKLE

IT'S OPENING,
BUT WILL IT HOLD?!
NEVER-NEVER USED
SO MUCH POWER!

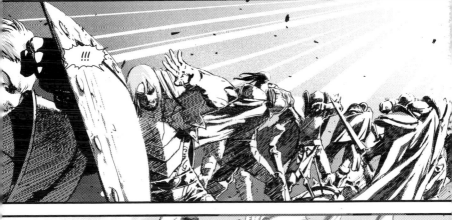

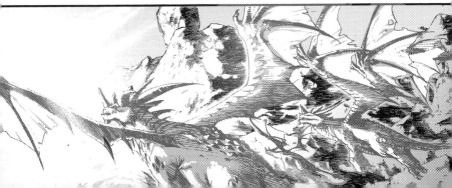

FWOOOOOM!!!

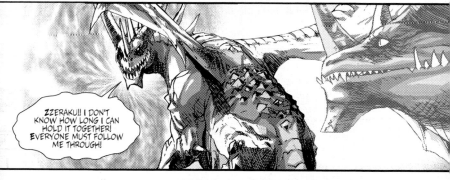

ZZERAKU!! I DON'T KNOW HOW LONG I CAN HOLD IT TOGETHER! EVERYONE MUST FOLLOW ME THROUGH!

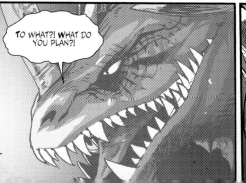

TO WHAT?! WHAT DO YOU PLAN?!

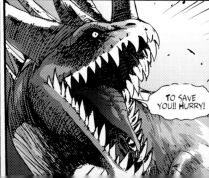

TO SAVE YOU!! HURRY!

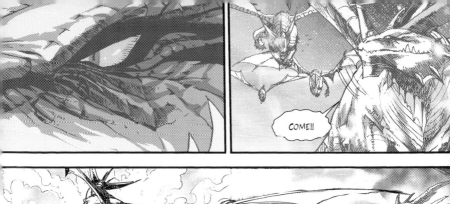

COME!!

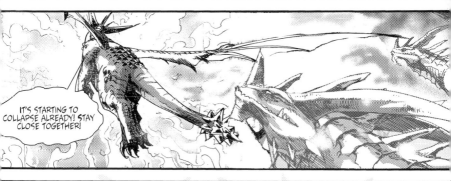

IT'S STARTING TO COLLAPSE ALREADY! STAY CLOSE TOGETHER!

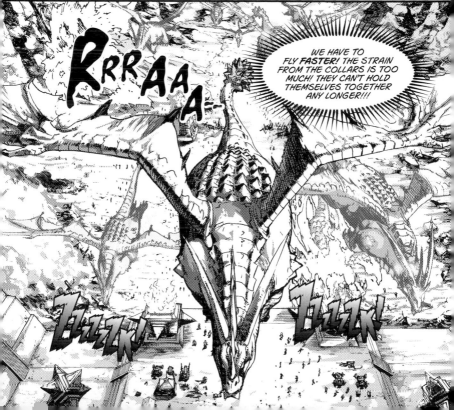

RRRAAA

WE HAVE TO FLY *FASTER!* THE STRAIN FROM THE COLLARS IS TOO MUCH! THEY CAN'T HOLD THEMSELVES TOGETHER ANY LONGER!!!

BBZZZK!

BBZZZK!

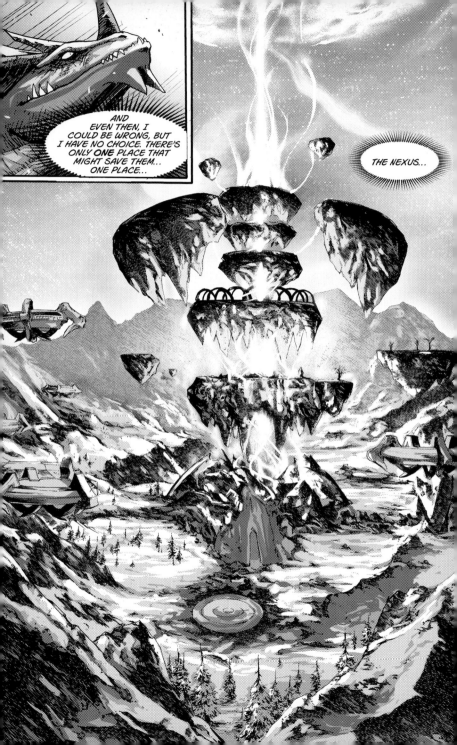

CHAPTER FIVE
NEXUS

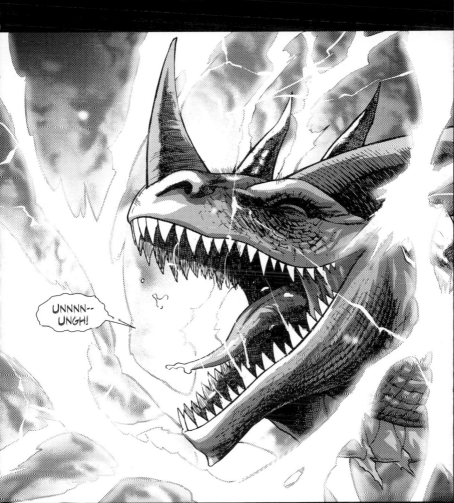

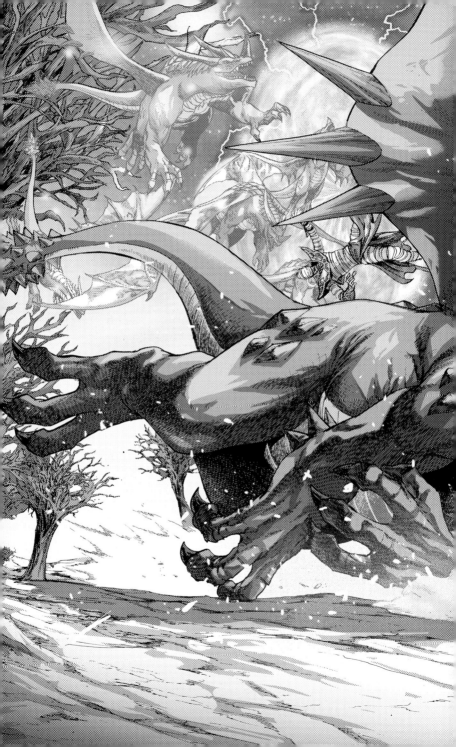

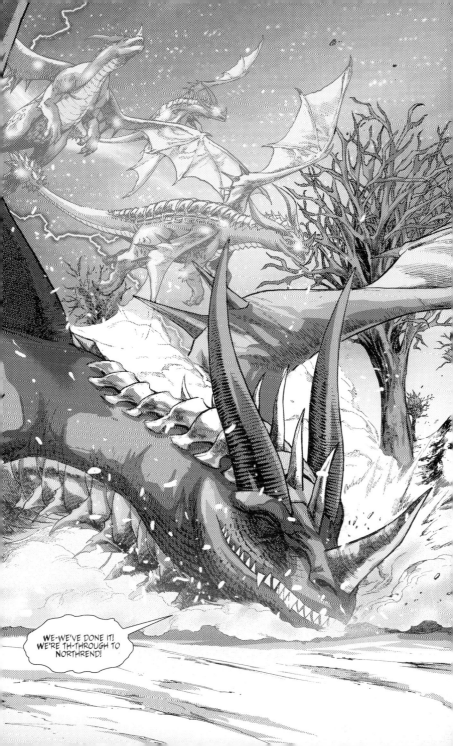

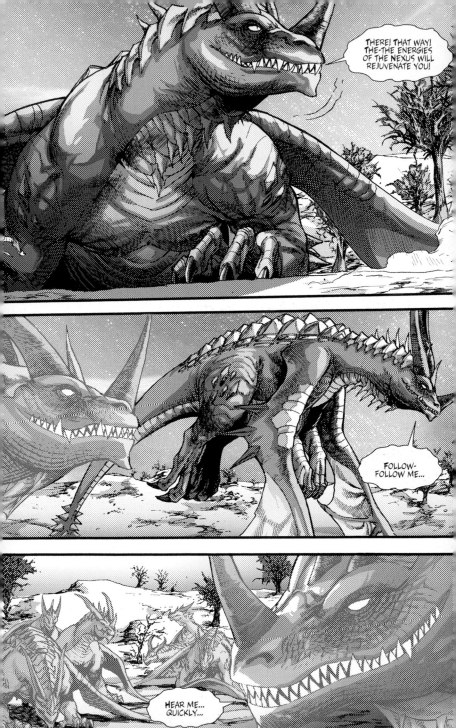

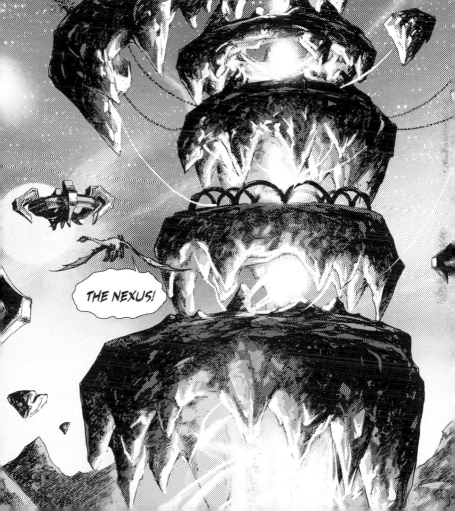

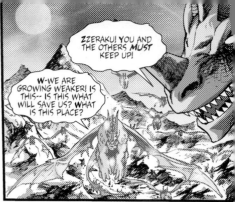

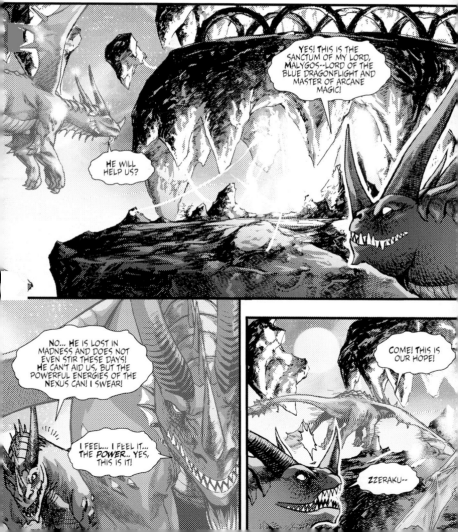

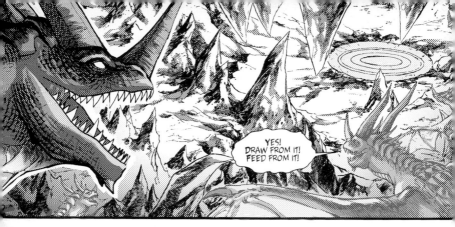

YES! DRAW FROM IT! FEED FROM IT!

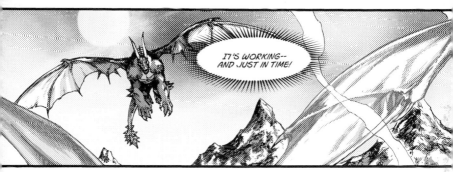

IT'S WORKING-- AND JUST IN TIME!

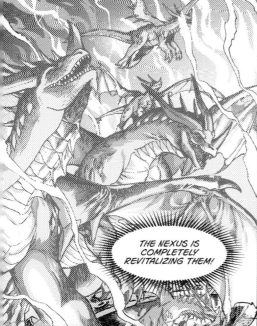

THE NEXUS IS COMPLETELY REVITALIZING THEM!

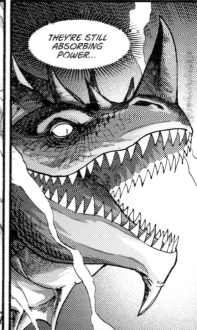

THEY'RE STILL ABSORBING POWER...

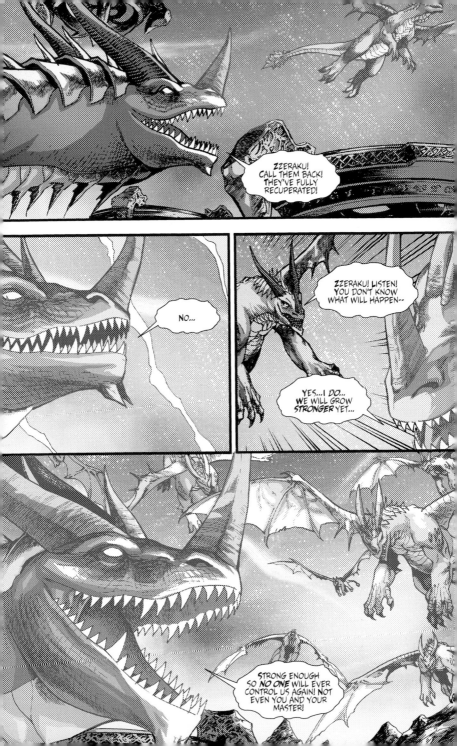

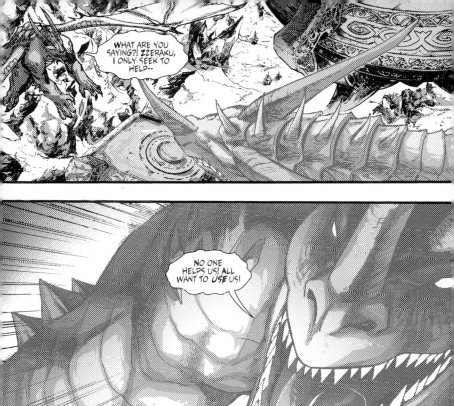
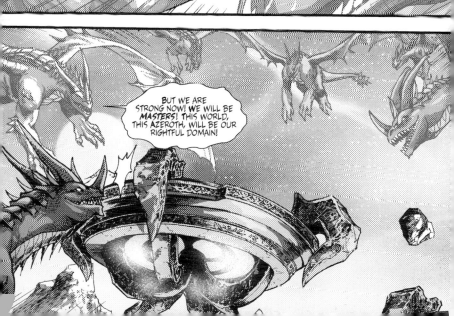

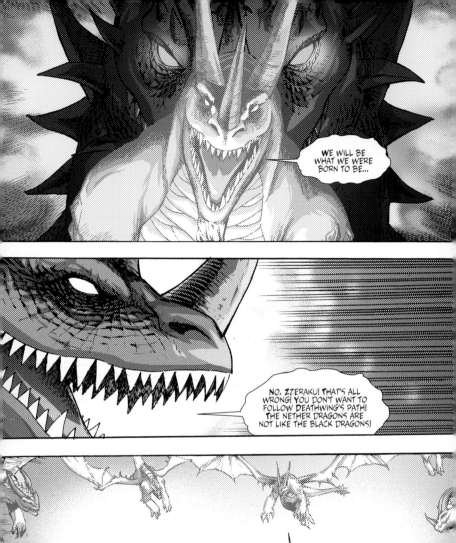
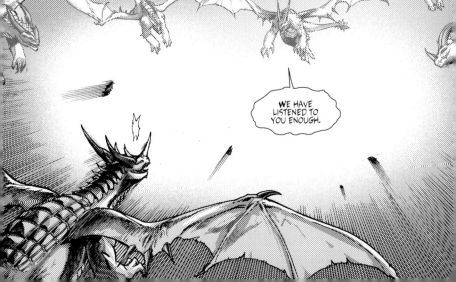

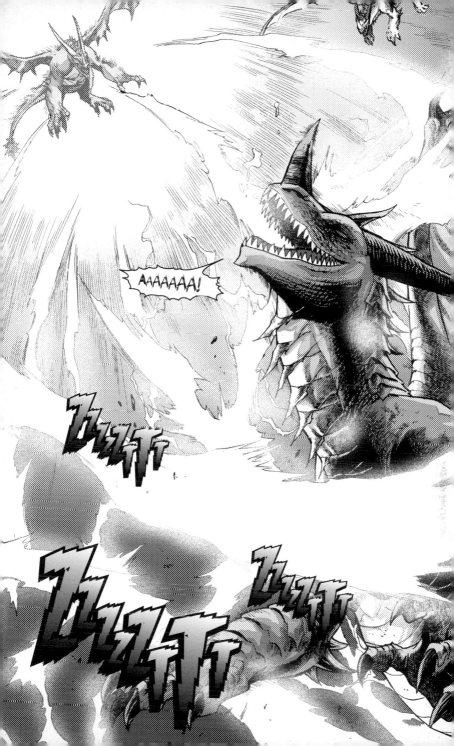

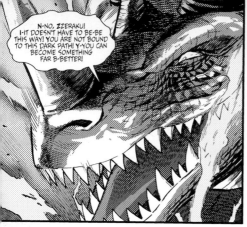

N-NO, ZZERAKU! I-IT DOESN'T HAVE TO BE-BE THIS WAY! YOU ARE NOT BOUND TO THIS DARK PATH! Y-YOU CAN BECOME SOMETHING FAR B-BETTER!

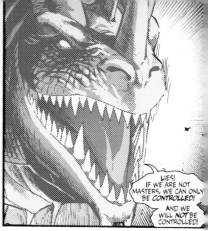

LIES! IF WE ARE NOT MASTERS, WE CAN ONLY BE *CONTROLLED!*

AND WE WILL *NOT* BE CONTROLLED!

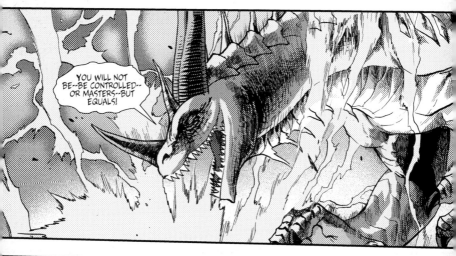

YOU WILL NOT BE--BE CONTROLLED-- OR MASTERS--BUT EQUALS!

EQUALS?

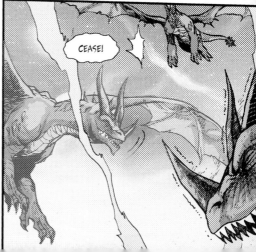

CEASE!

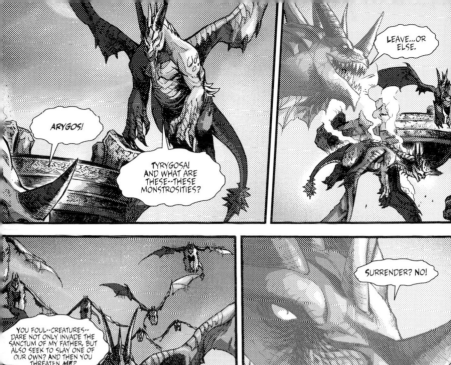

ARYGOS!

TYRYGOSA! AND WHAT ARE THESE--THESE MONSTROSITIES?

LEAVE...OR ELSE.

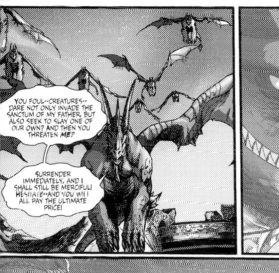

YOU FOUL--CREATURES-- DARE NOT ONLY INVADE THE SANCTUM OF MY FATHER, BUT ALSO SEEK TO SLAY ONE OF OUR OWN? AND THEN YOU THREATEN ME?

SURRENDER IMMEDIATELY, AND I SHALL STILL BE MERCIFUL! HESITATE--AND YOU WILL ALL PAY THE ULTIMATE PRICE!

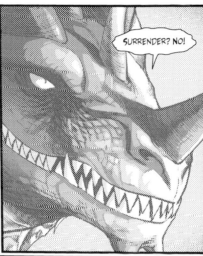

SURRENDER? NO!

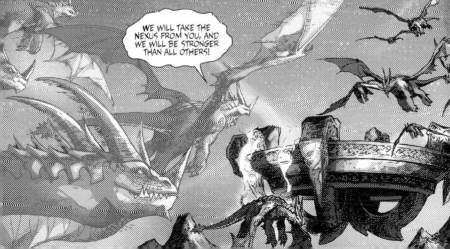

WE WILL TAKE THE NEXUS FROM YOU, AND WE WILL BE STRONGER THAN ALL OTHERS!

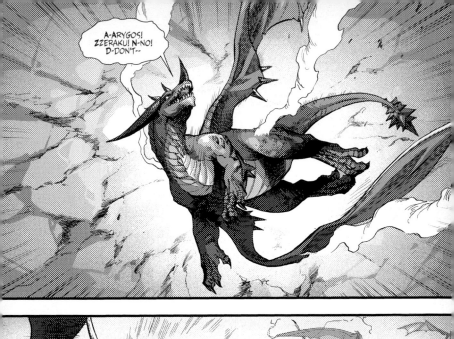

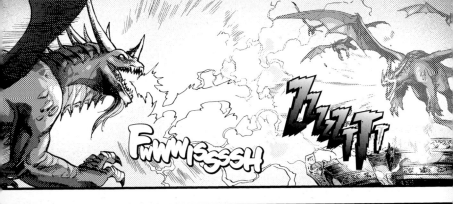

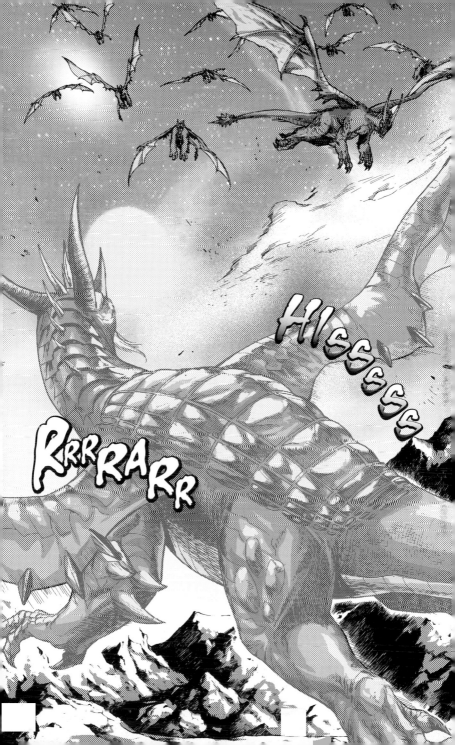

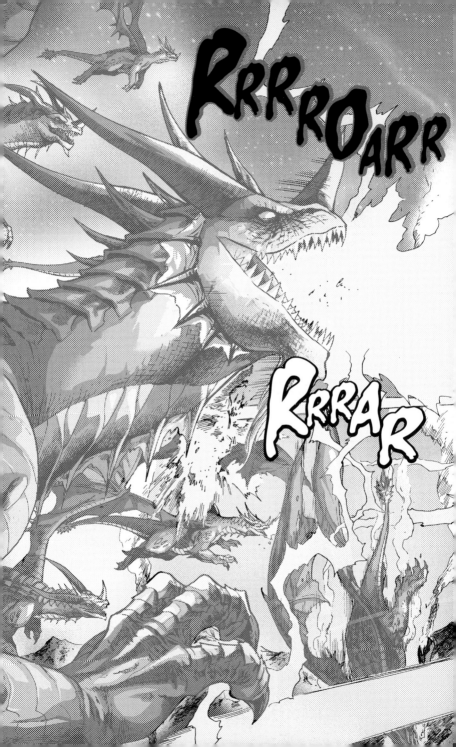

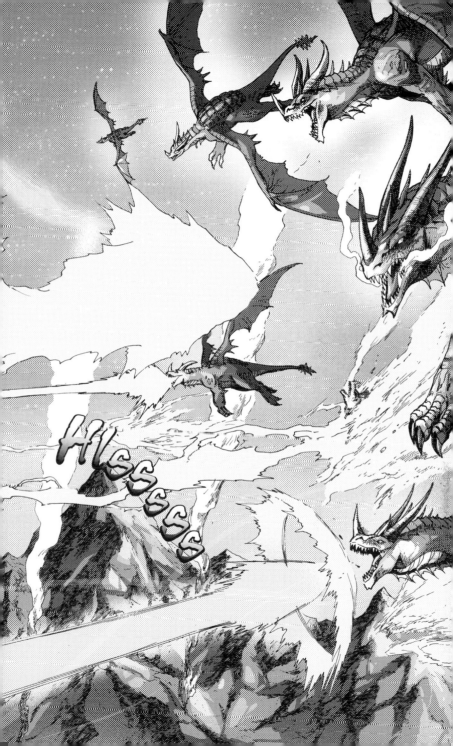

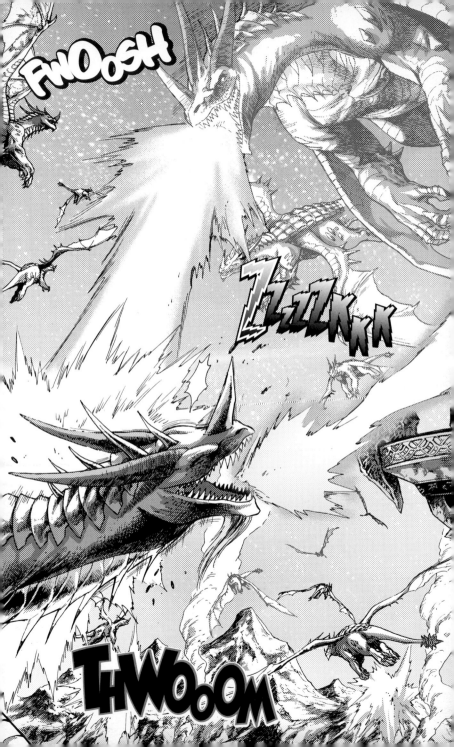

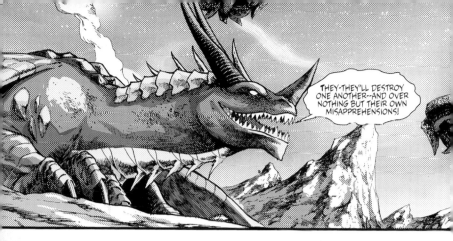

THEY--THEY'LL DESTROY ONE ANOTHER--AND OVER NOTHING BUT THEIR OWN MISAPPREHENSIONS!

THEY HAVE TO BE STOPPED. PERHAPS...

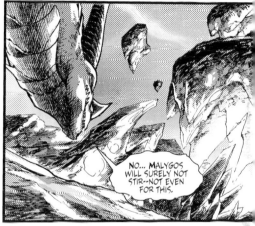

NO... MALYGOS WILL SURELY NOT STIR--NOT EVEN FOR THIS.

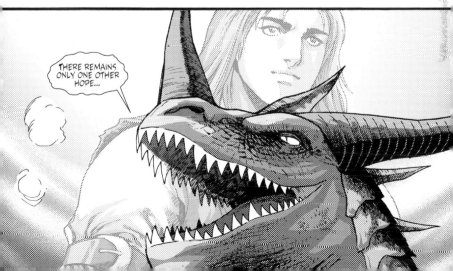

THERE REMAINS ONLY ONE OTHER HOPE...

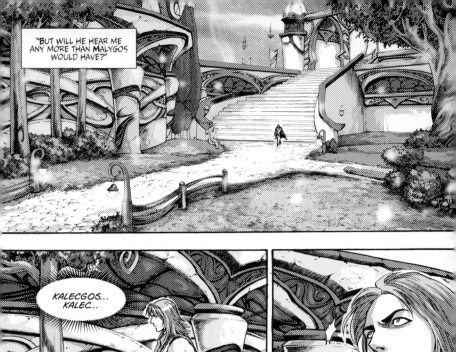

"BUT WILL HE HEAR ME ANY MORE THAN MALYGOS WOULD HAVE?"

KALECGOS... KALEC...

WHO IS IT? TYRI?

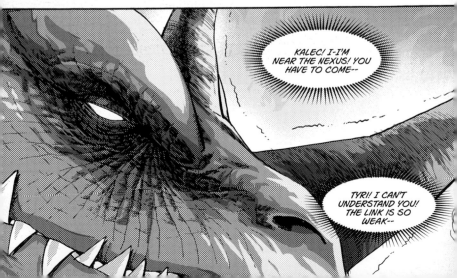

KALEC! I-I'M NEAR THE NEXUS! YOU HAVE TO COME--

TYRI!! I CAN'T UNDERSTAND YOU! THE LINK IS SO WEAK--

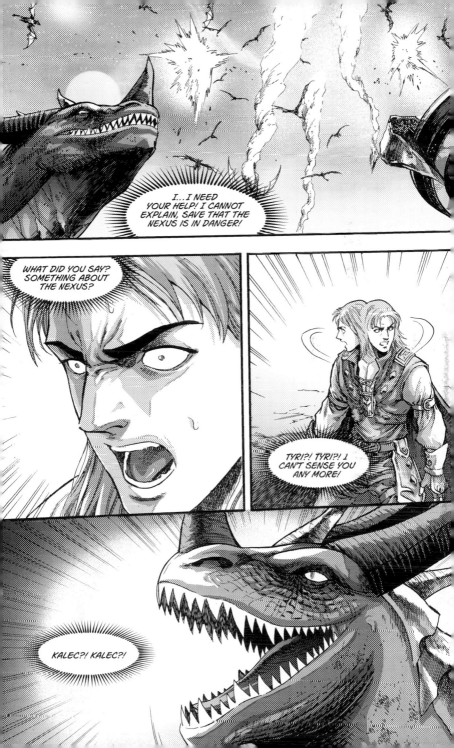

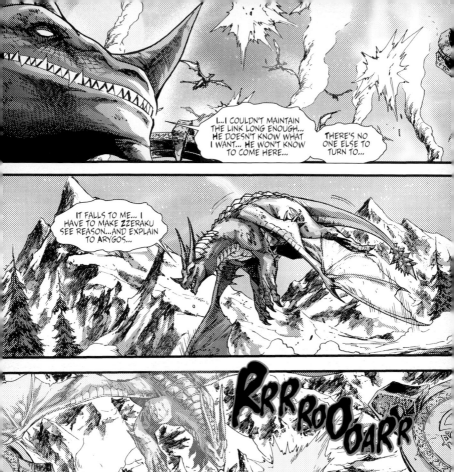

I...I COULDN'T MAINTAIN THE LINK LONG ENOUGH... HE DOESN'T KNOW WHAT I WANT... HE WON'T KNOW TO COME HERE...

THERE'S NO ONE ELSE TO TURN TO...

IT FALLS TO ME... I HAVE TO MAKE ZZERAKU SEE REASON...AND EXPLAIN TO ARYGOS...

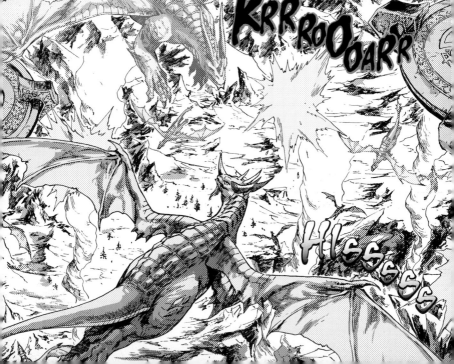

RRRROOOARR

HISSSSS

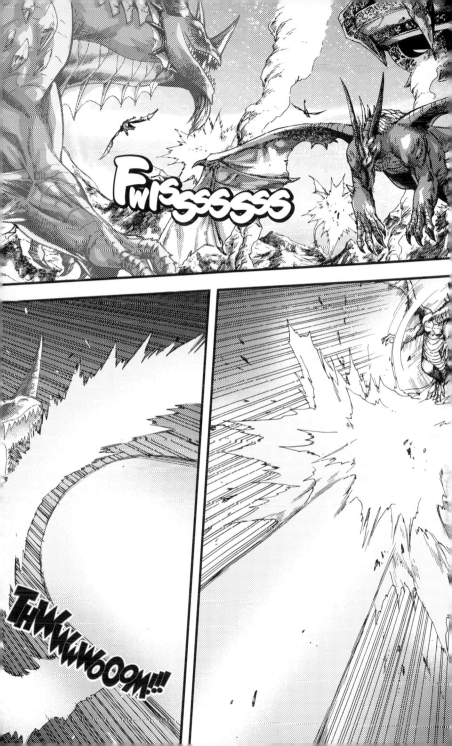

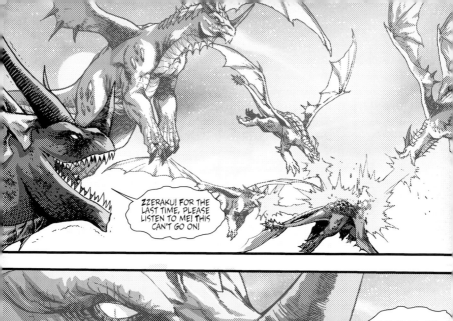

ZZERAKU! FOR THE LAST TIME, PLEASE LISTEN TO ME! THIS CAN'T GO ON!

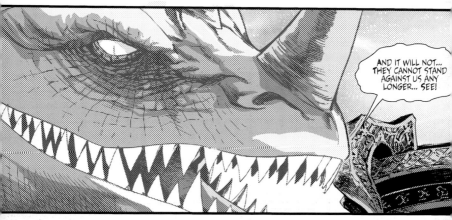

AND IT WILL NOT... THEY CANNOT STAND AGAINST US ANY LONGER... SEE!

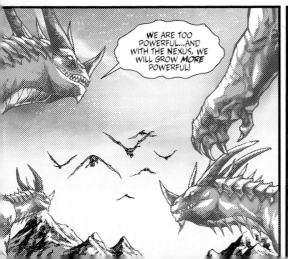

WE ARE TOO POWERFUL...AND WITH THE NEXUS, WE WILL GROW *MORE* POWERFUL!

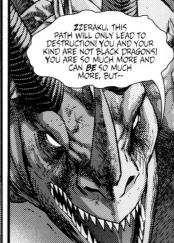

ZZERAKU, THIS PATH WILL ONLY LEAD TO DESTRUCTION! YOU AND YOUR KIND ARE NOT BLACK DRAGONS! YOU ARE SO MUCH MORE AND CAN *BE* SO MUCH MORE, BUT--

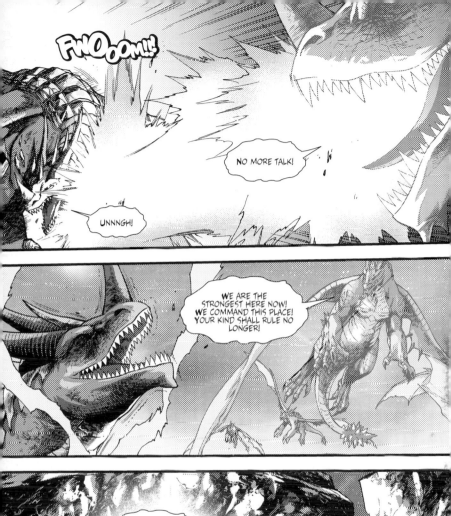

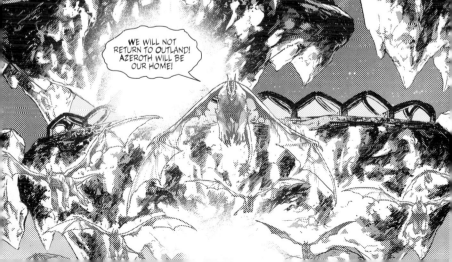

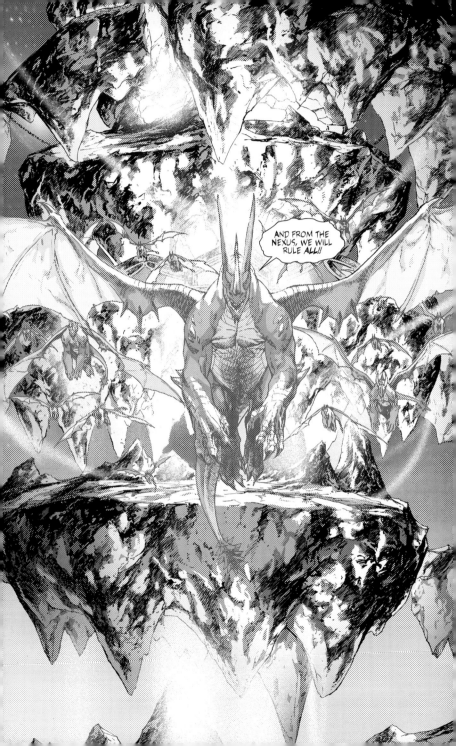

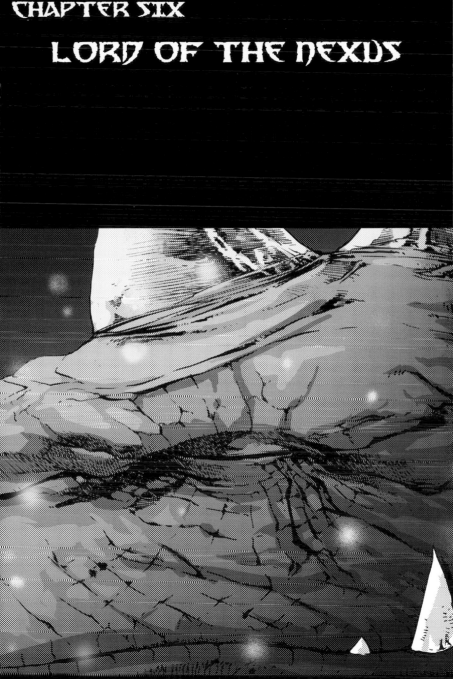

CHAPTER SIX
LORD OF THE NEXUS

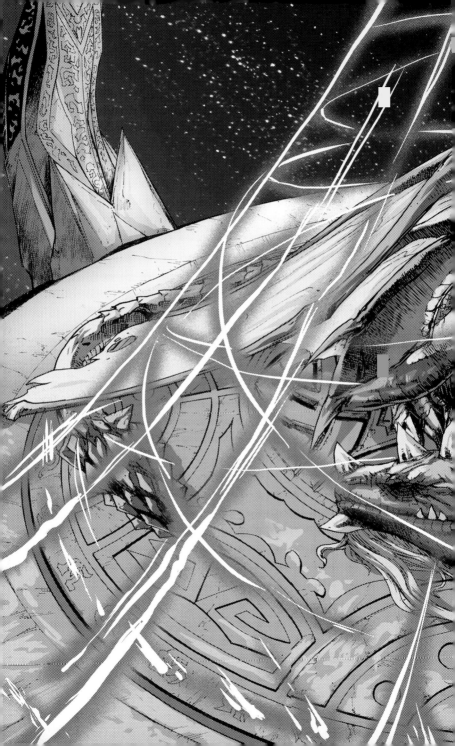

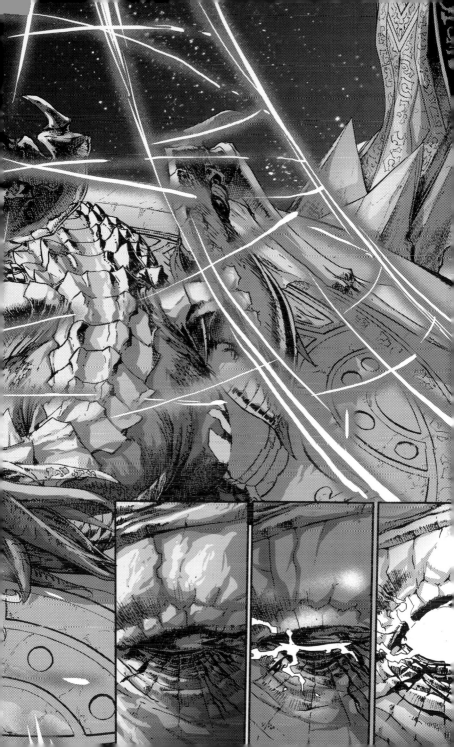

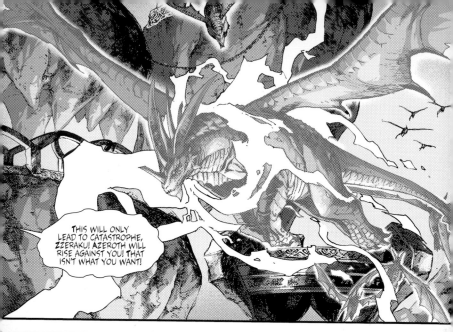

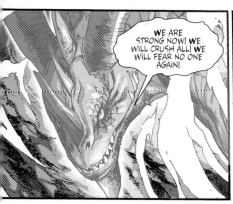

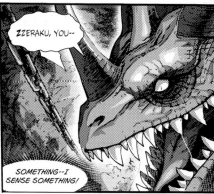

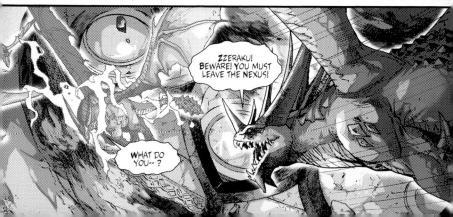

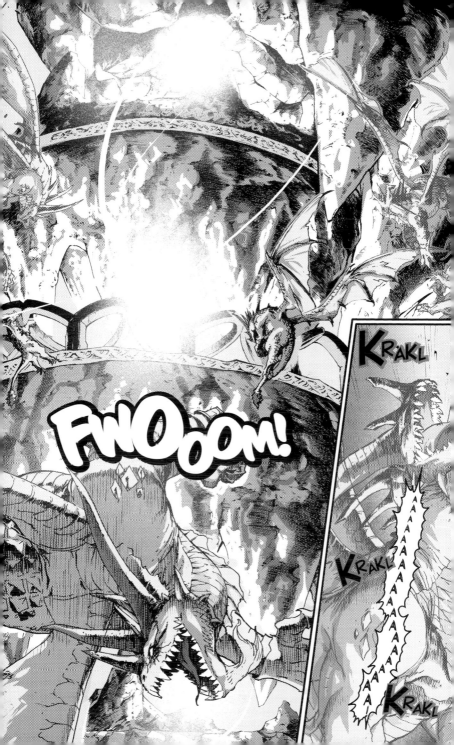

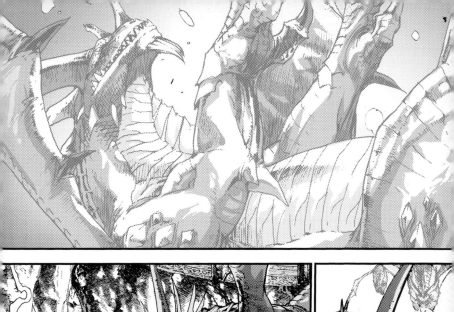

OH, ZZERAKU! OH, NO!

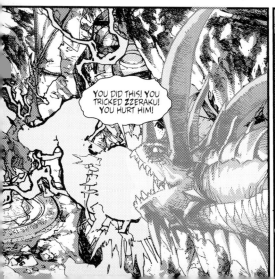

YOU DID THIS! YOU TRICKED ZZERAKU! YOU HURT HIM!

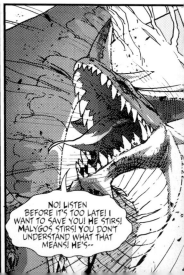

NO! LISTEN BEFORE IT'S TOO LATE! I WANT TO SAVE YOU! HE STIRS! MALYGOS STIRS! YOU DON'T UNDERSTAND WHAT THAT MEANS! HE'S--

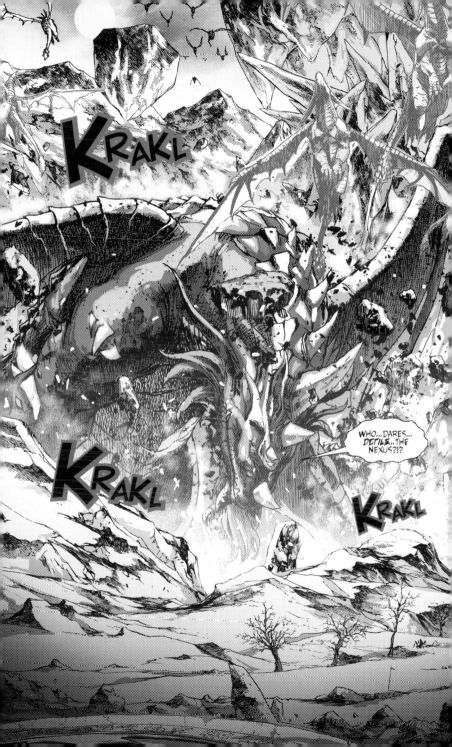

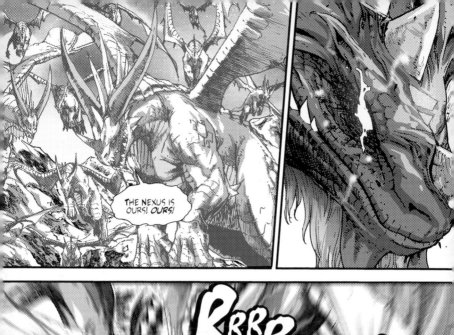

THE NEXUS IS
OURS! *OURS!*

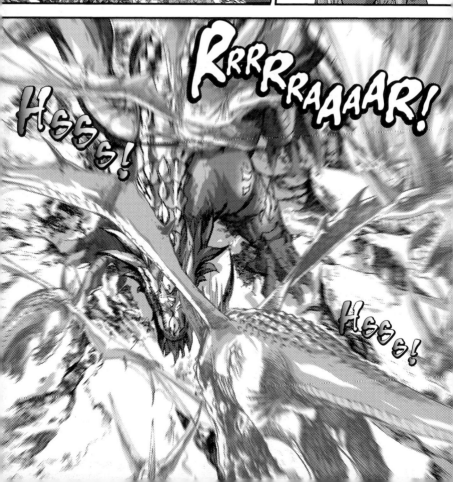

RRRRRAAAAR!

HSSS!

HSSS!

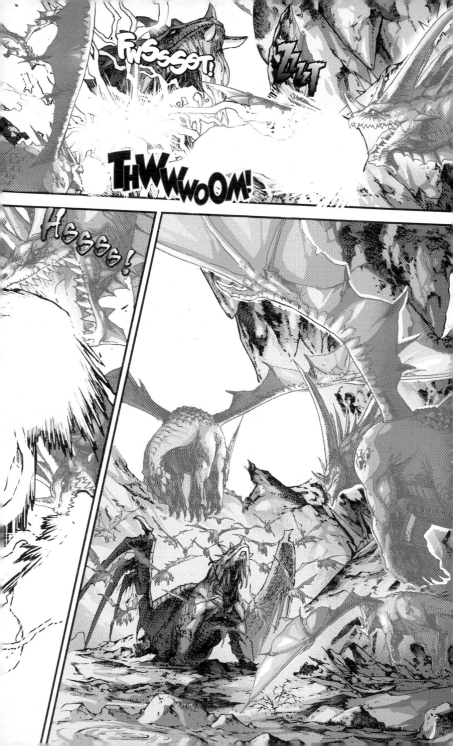

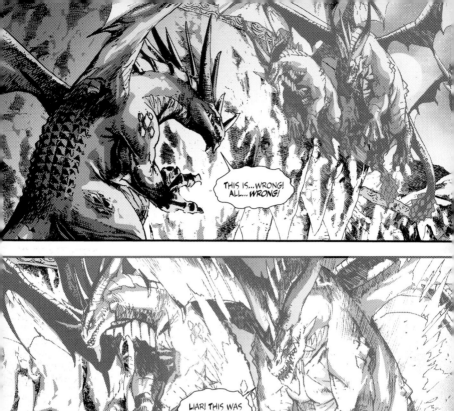

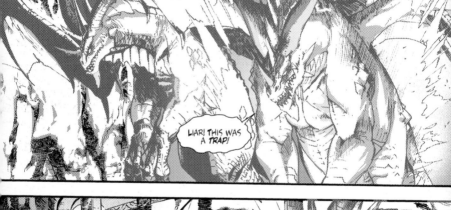

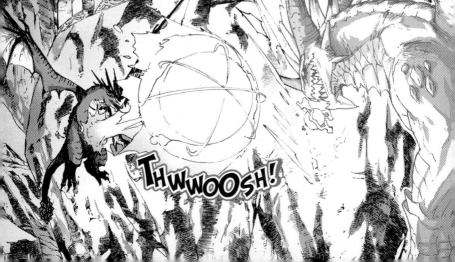

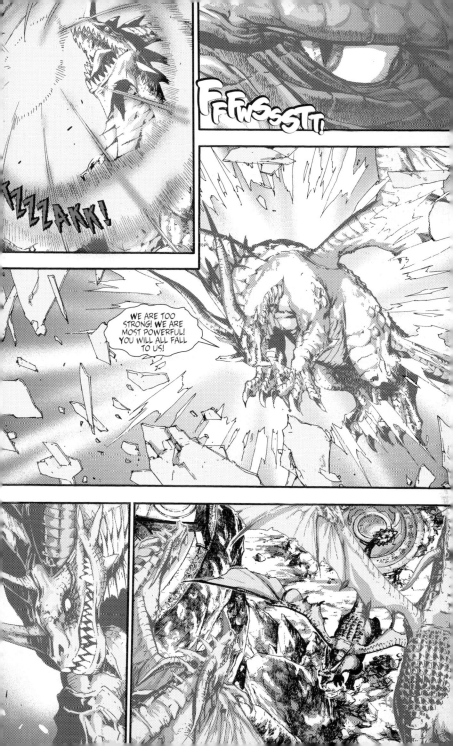

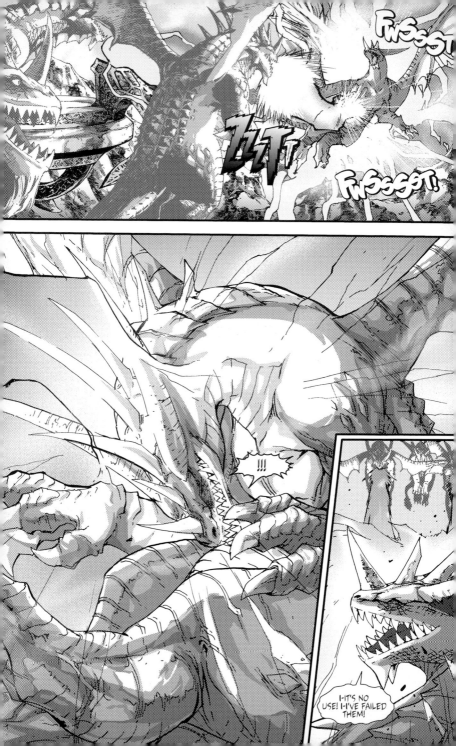

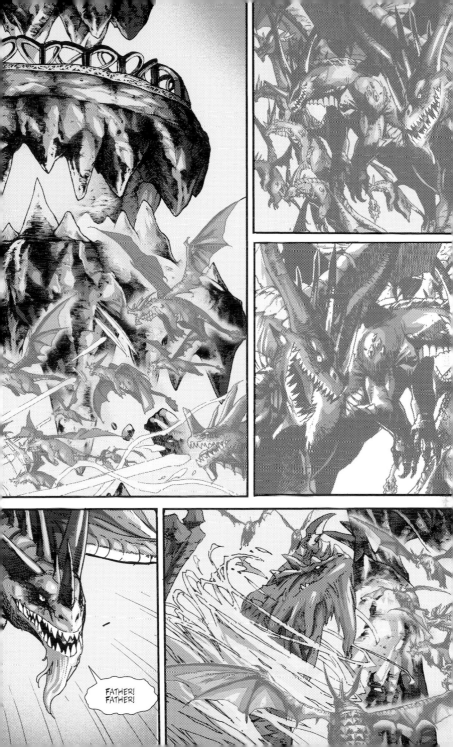

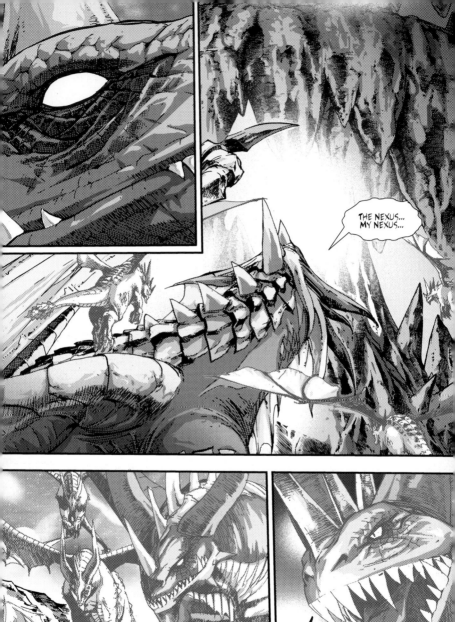
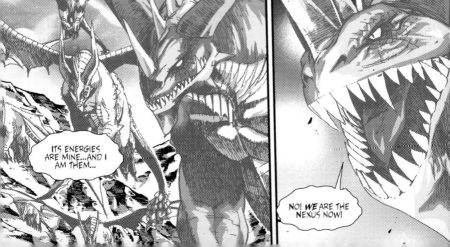

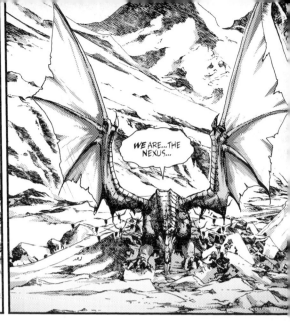

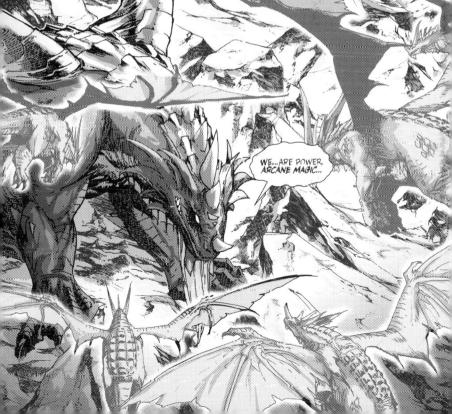

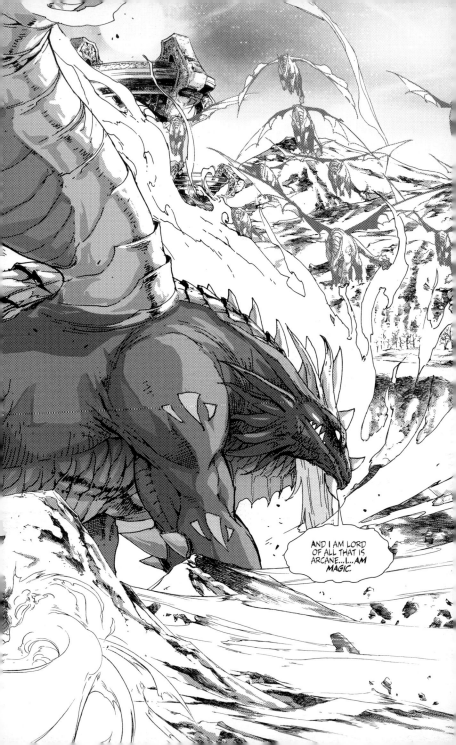

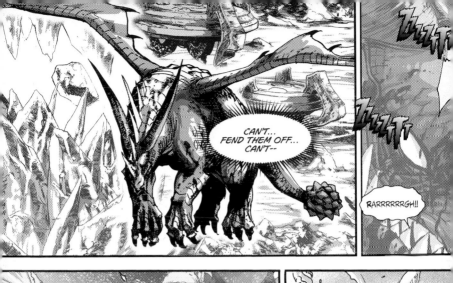

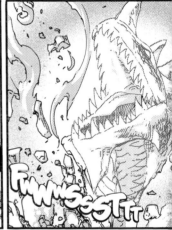

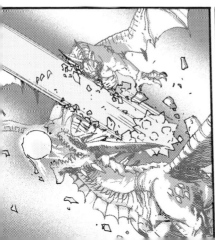

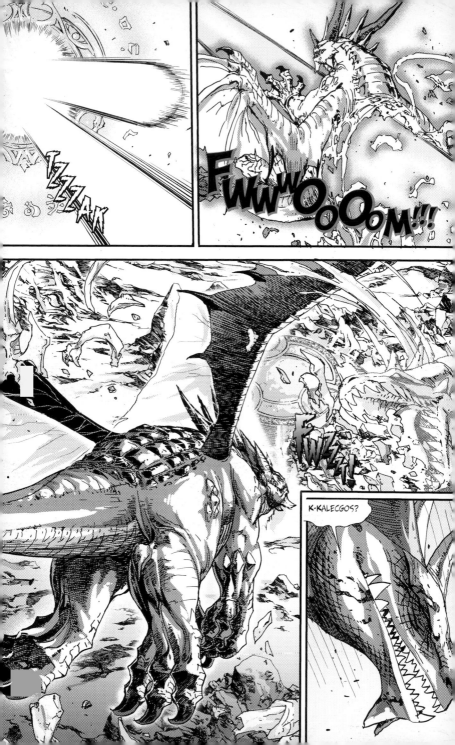

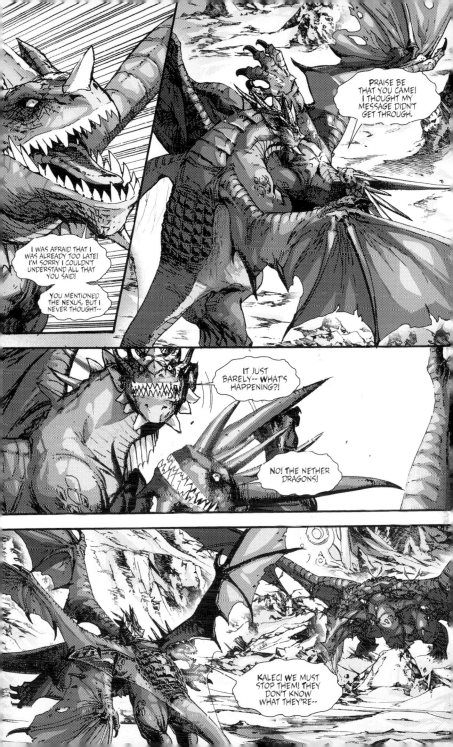

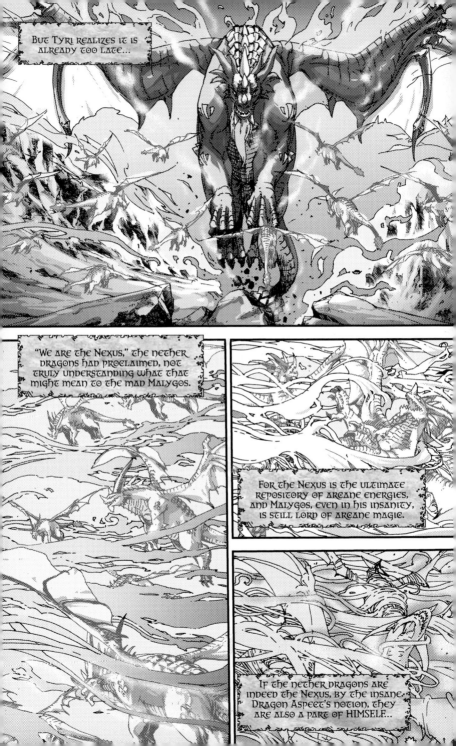

BUT TYRI REALIZES IT IS
ALREADY TOO LATE...

"WE ARE THE NEXUS," THE NETHER
DRAGONS HAD PROCLAIMED, NOT
TRULY UNDERSTANDING WHAT THAT
MIGHT MEAN TO THE MAD MALYGOS.

FOR THE NEXUS IS THE ULTIMATE
REPOSITORY OF ARCANE ENERGIES,
AND MALYGOS, EVEN IN HIS INSANITY,
IS STILL LORD OF ARCANE MAGIC.

IF THE NETHER DRAGONS ARE
INDEED THE NEXUS, BY THE INSANE
DRAGON ASPECT'S NOTION, THEY
ARE ALSO A PART OF HIMSELF...

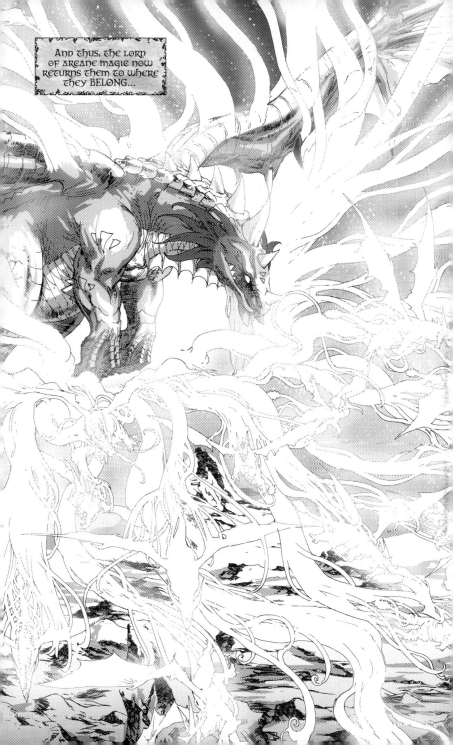

AND THUS, THE LORD OF ARCANE MAGIC NOW RETURNS THEM TO WHERE THEY BELONG...

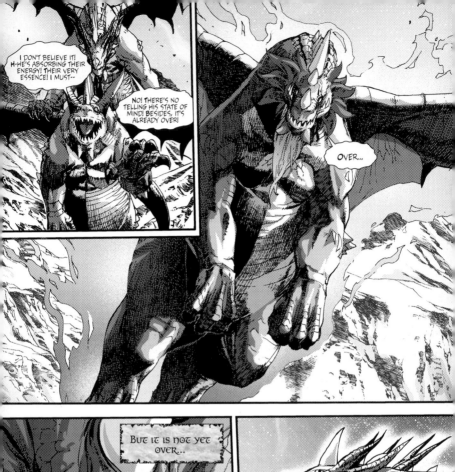

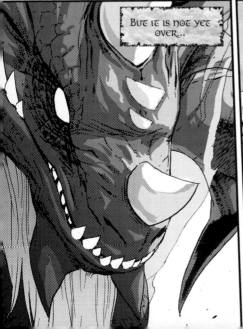

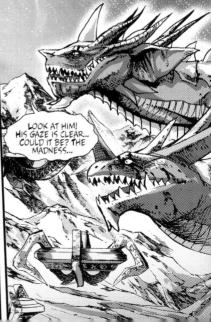

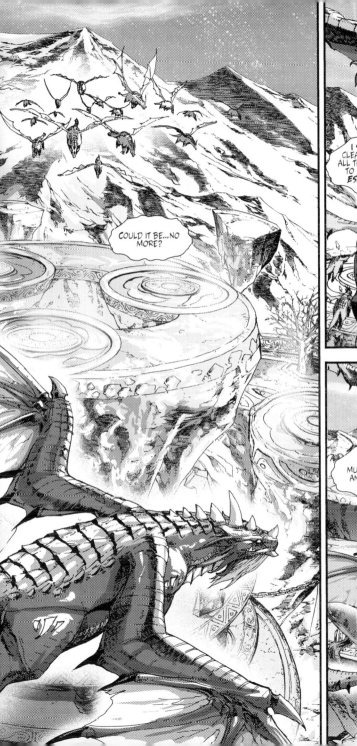

COULD IT BE...NO MORE?

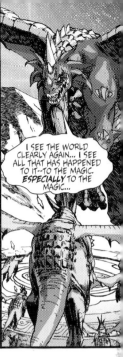

I SEE THE WORLD CLEARLY AGAIN... I SEE ALL THAT HAS HAPPENED TO IT--TO THE MAGIC. *ESPECIALLY* TO THE MAGIC...

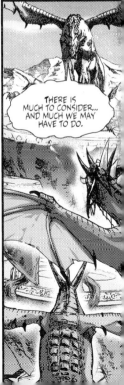

THERE IS MUCH TO CONSIDER... AND MUCH WE MAY HAVE TO DO.

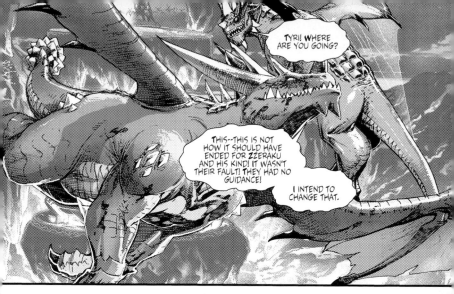

TYRI! WHERE ARE YOU GOING?

THIS--THIS IS NOT HOW IT SHOULD HAVE ENDED FOR ZZERAKU AND HIS KIND! IT WASN'T THEIR FAULT! THEY HAD NO GUIDANCE!

I INTEND TO CHANGE THAT.

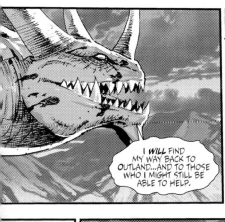

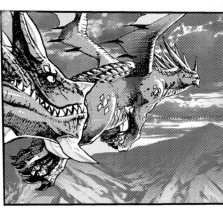

I WILL FIND MY WAY BACK TO OUTLAND...AND TO THOSE WHO I MIGHT STILL BE ABLE TO HELP.

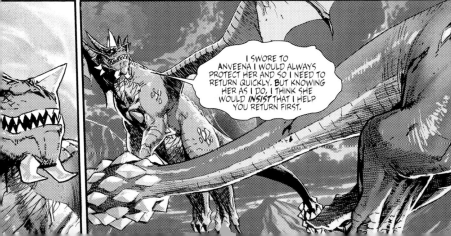

I SWORE TO ANVEENA I WOULD ALWAYS PROTECT HER AND SO I NEED TO RETURN QUICKLY. BUT KNOWING HER AS I DO, I THINK SHE WOULD INSIST THAT I HELP YOU RETURN FIRST.

HMM, NO RETURN RIDE THERE... NO MATTER. THE PROFIT POTENTIAL FOR THAT TERRITORY HAS PLAYED ITSELF OUT, I THINK...

AND THAT HARDLY SEEMS A PLACE TO FIND AN EAGER CUSTOMER...

STILL... SOMEWHERE IN THIS NEW WORLD THERE SHOULD BE PLENTY EAGER TO SAMPLE THE WARES I CAN OFFER THEM...

ALL THEY'LL HAVE TO DO IS BE WILLING TO PAY THE *PRICE*...

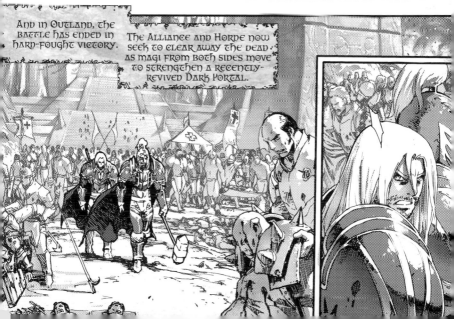

AND IN OUTLAND, THE BATTLE HAS ENDED IN HARD-FOUGHT VICTORY. The Alliance and Horde now seek to clear away the dead as magi from both sides move to strengthen a recently-revived Dark Portal.

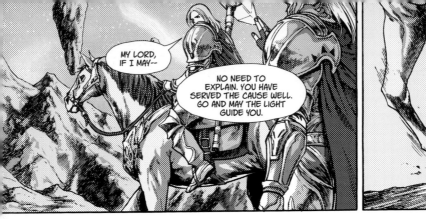

MY LORD, IF I MAY--

NO NEED TO EXPLAIN. YOU HAVE SERVED THE CAUSE WELL. GO AND MAY THE LIGHT GUIDE YOU.

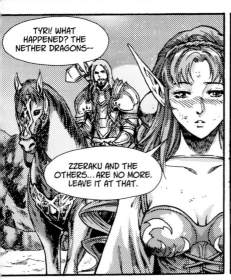

TYRI! WHAT HAPPENED? THE NETHER DRAGONS--

ZZERAKU AND THE OTHERS... ARE NO MORE. LEAVE IT AT THAT.

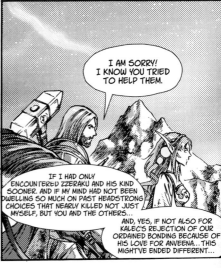

I AM SORRY! I KNOW YOU TRIED TO HELP THEM.

IF I HAD ONLY ENCOUNTERED ZZERAKU AND HIS KIND SOONER. AND IF MY MIND HAD NOT BEEN DWELLING SO MUCH ON PAST HEADSTRONG CHOICES THAT NEARLY KILLED NOT JUST MYSELF, BUT YOU AND THE OTHERS...

AND, YES, IF NOT ALSO FOR KALEC'S REJECTION OF OUR ORDAINED BONDING BECAUSE OF HIS LOVE FOR ANVEENA... THIS MIGHT'VE ENDED DIFFERENT...

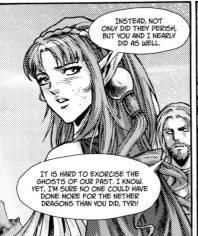

INSTEAD, NOT ONLY DID THEY PERISH, BUT YOU AND I NEARLY DID AS WELL.

IT IS HARD TO EXORCISE THE GHOSTS OF OUR PAST. I KNOW. YET, I'M SURE NO ONE COULD HAVE DONE MORE FOR THE NETHER DRAGONS THAN YOU DID, TYRI!

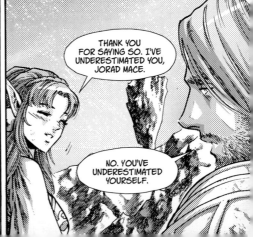

THANK YOU FOR SAYING SO. I'VE UNDERESTIMATED YOU, JORAD MACE.

NO. YOU'VE UNDERESTIMATED YOURSELF.

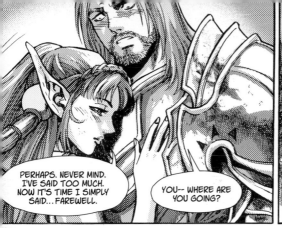

PERHAPS. NEVER MIND. I'VE SAID TOO MUCH. NOW IT'S TIME I SIMPLY SAID...FAREWELL.

YOU-- WHERE ARE YOU GOING?

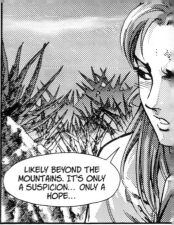

LIKELY BEYOND THE MOUNTAINS. IT'S ONLY A SUSPICION... ONLY A HOPE...

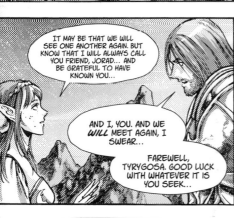

IT MAY BE THAT WE WILL SEE ONE ANOTHER AGAIN. BUT KNOW THAT I WILL ALWAYS CALL YOU FRIEND, JORAD... AND BE GRATEFUL TO HAVE KNOWN YOU...

AND I, YOU. AND WE *WILL* MEET AGAIN, I SWEAR...

FAREWELL, TYRYGOSA. GOOD LUCK WITH WHATEVER IT IS YOU SEEK...

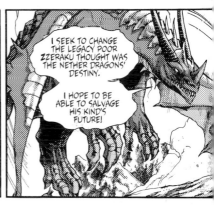

I SEEK TO CHANGE THE LEGACY POOR ZZERAKU THOUGHT WAS THE NETHER DRAGONS' DESTINY.

I HOPE TO BE ABLE TO SALVAGE HIS KIND'S FUTURE!

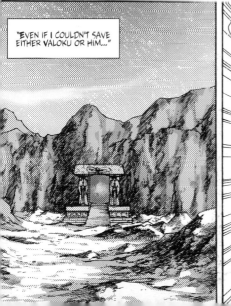

"EVEN IF I COULDN'T SAVE EITHER VALOKU OR HIM..."

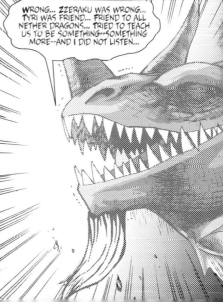

WRONG... ZZERAKU WAS WRONG... TYRI WAS FRIEND... FRIEND TO ALL NETHER DRAGONS... TRIED TO TEACH US TO BE SOMETHING--SOMETHING MORE--AND I DID NOT LISTEN...

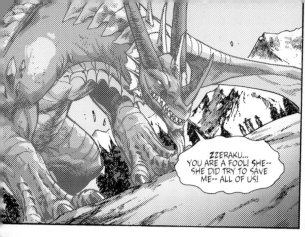

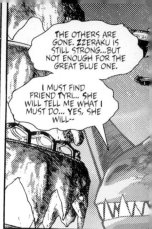

THE OTHERS ARE GONE. ZZERAKU IS STILL STRONG...BUT NOT ENOUGH FOR THE GREAT BLUE ONE.

I MUST FIND FRIEND TYRI... SHE WILL TELL ME WHAT I MUST DO... YES, SHE WILL--

ZZERAKU... YOU ARE A FOOL! SHE-- SHE DID TRY TO SAVE ME-- ALL OF US!

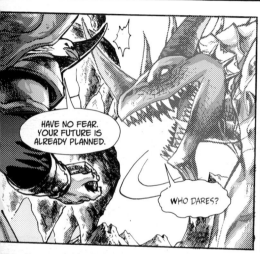

HAVE NO FEAR. YOUR FUTURE IS ALREADY PLANNED.

WHO DARES?

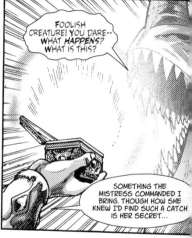

FOOLISH CREATURE! YOU DARE-- WHAT HAPPENS? WHAT IS THIS?

SOMETHING THE MISTRESS COMMANDED I BRING. THOUGH HOW SHE KNEW I'D FIND SUCH A CATCH IS HER SECRET...

AAAAAAA!!!!

BUT THEN, SHE HAS MANY SECRETS... INCLUDING ONE FOR WHICH YOU'LL PROVE QUITE INVALUABLE.

ONCE WE RETURN WITH YOU TO GRIM BATOL...*

*FOR MORE DETAILS ON THIS, SEE THE NOVEL, NIGHT OF THE DRAGON...

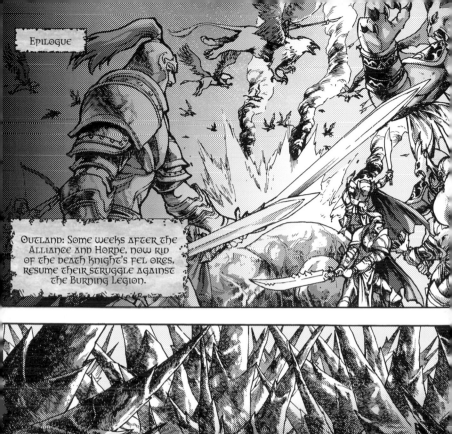

EPILOGUE

OUTLAND: SOME WEEKS AFTER THE ALLIANCE AND HORDE, NOW RID OF THE DEATH KNIGHT'S FEL ORCS, RESUME THEIR STRUGGLE AGAINST THE BURNING LEGION.

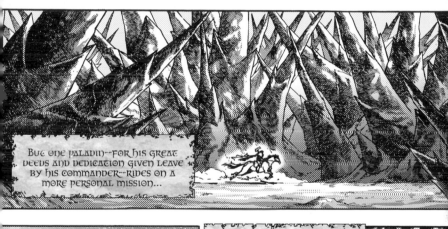

BUT ONE PALADIN--FOR HIS GREAT DEEDS AND DEDICATION GIVEN LEAVE BY HIS COMMANDER--RIDES ON A MORE PERSONAL MISSION...

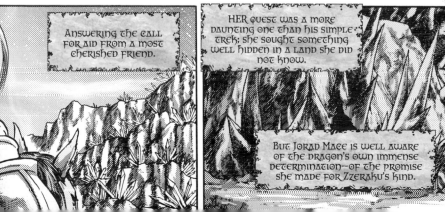

ANSWERING THE CALL FOR AID FROM A MOST CHERISHED FRIEND.

HER QUEST WAS A MORE DAUNTING ONE THAN HIS SIMPLE TREK; SHE SOUGHT SOMETHING WELL HIDDEN IN A LAND SHE DID NOT KNOW.

BUT JORAD MACE IS WELL AWARE OF THE DRAGON'S OWN IMMENSE DETERMINATION--OF THE PROMISE SHE MADE FOR ZZERAHU'S KIND.

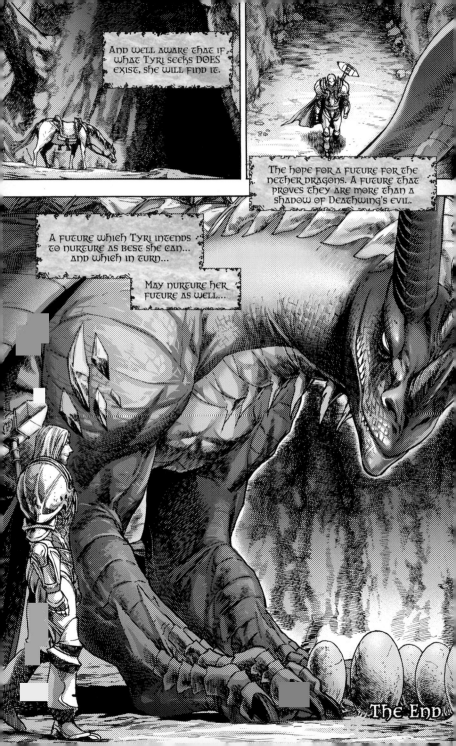

AND WELL AWARE THAT IF WHAT TYRI SEEKS DOES EXIST, SHE WILL FIND IT.

THE HOPE FOR A FUTURE FOR THE NETHER DRAGONS. A FUTURE THAT PROVES THEY ARE MORE THAN A SHADOW OF DEATHWING'S EVIL.

A FUTURE WHICH TYRI INTENDS TO NURTURE AS BEST SHE CAN... AND WHICH IN TURN...

MAY NURTURE HER FUTURE AS WELL...

THE END

SHADOW WING SPECIAL THANKS

We hope you enjoyed *Nexus Point*, the thrilling volume two finale to *World of Warcraft: Shadow Wing*! On behalf of Blizzard Entertainment, we want to thank you for supporting this series!

Many thanks goes to the dynamic duo of *World of Warcraft* manga, Richard A. Knaack and Jae-Hwan Kim for weaving awesome stories in Azeroth for five years straight. You two should TOTALLY form your own guild now...!

This book represents not just an end to the series, but the end of three years of thrilling *World of Warcraft* manga. It has been a rollercoaster ride of late-night art revisions, last-minute script tweaks, and races to the printer finish line, but we have somehow always prevailed in the face of seemingly insurmountable odds!

And by we, I mean ALL of the artists, writers, and Blizzard team members who have worked their butts off over the last three years to get these books out the door and into the hands of you wonderful fans. Many thanks goes to Jason Bischoff, Joshua Horst, James Waugh, Micky Neilson, Evelyn Fredericksen, Samwise Didier, Tommy Newcomer, Cameron Dayton and Chris Metzen.

Our goal when we embarked on this journey was to create the most well written and visually compelling stories possible. *World of Warcraft* is no longer just a game for fans; it's a way of life. Fans play the game to escape their problems for a few hours, converse with friends, and have the adventure of their cyber-lifetimes. It is my great hope--and wish--that we have achieved that level of escapism with our *World of Warcraft* manga.

But, equally important, now that the job has ended and the publishing battlefield is finally still...

Now I finally have time to play the game.

- Troy Lewter
Editor

CREATOR BIOS

RICHARD A. KNAAK

Richard A. Knaak is the New York Times and USA Today bestselling fantasy author of 40 novels and over a dozen short stories, including most recently the national bestseller, *World of Warcraft: Stormrage*. He is also well known for such favorites as *The Legend of Huma* & *The Minotaur Wars* for Dragonlance, the *War of the Ancients* trilogy for *Warcraft*, and his own *Dragonrealm* series. In addition to *Warcraft: The Sunwell Trilogy*, he is the author of five short stories featured in *Warcraft: Legends* Volumes 1-5. He also recently released *The Gargoyle King*, the third in his *Ogre Titans* saga for Dragonlance and *Legends of the Dragonrealm*, which combines the first three novels of his world. To find out more about Richard's projects, visit his website at www.richardaknaak.com.

JAE-HWAN KIM

Born in 1971 in Korea, Jae-Hwan Kim's best-known manga works include *Rainbow*, *Combat Metal HeMoSoo* and *King of Hell*, a series published by TOKYOPOP. Along with being the creator of *War Angels* for TOKYOPOP, Jae-Hwan is the artist for *Warcraft: The Sunwell Trilogy*, as well as Richard Knaak's four-part short story featured in *Warcraft: Legends* Volumes 1-4.

NEXUS POINT Q & A

A journey that began with the smash-hit *The Sunwell Trilogy* has finally come to a close with *Dragons of Outland: Nexus Point*, concluding the epic journey undertaken by Jorad and Tyri several years ago. In honor of this momentous occasion, we thought it would be fantastic to get scribe supreme Richard Knaak's final thoughts on this manga series!

Tell us about the origin of *The Sunwell Trilogy*. Was this a story that you pitched? Or did you and Blizzard craft the story together?

I was asked to write a manga, with the understanding that they also wanted to introduce manga fans to the world. That required creating a story that first brought the reader some knowledge of the world, then leading them into a storyline more intricate. When I was told about the Sunwell and the fact that Blizzard wanted to resurrect it, I came up with the idea of Anveena. Blizzard liked the concept, asked for my initial synopsis, and then we worked together to craft the final storyline. Always someone who enjoys dragons, I wanted to use one as the main character and since blue dragons are drawn to magic and Blizzard wanted to highlight them, Kalecgos was crafted. After that, the other characters fell into place and the trilogy was born.

Jorad Mace and Tyri have become very prominent figures in *Warcraft* lore. What was the inspiration for these two unforgettable characters?

With Jorad Mace, it was my interest in the paladins in the game. I've always admired the best traits of that type of character, as witnessed in my novel, *The Legend of Huma*. I wanted one who had lived through troubles and so had lost his arrogance, but not his integrity. Jorad quickly became one of my favorites. As for Tyri, I wanted a strong female character that contrasted to the "innocent" one of Anveena and who also had interest in the male lead, Kalecgos. Tyri was also more brash, enabling me to throw her into situations and combat where the others might hesitate.

At times, there seems to be a little bit of romantic tension between Jorad and Tyri. Do you see their story as a kind of romance? Are they soul mates of some sort?

There is a bond between them, a closeness in part because of both being somewhat outcast among their own kind, but it's doubtful that it'll ever be more than a tension. Still, who knows? That's up to Blizzard in the end.

Both Jorad and Tyri have become NPCs in the *World of Warcraft* game! How did you react to their inclusion in the game world? And did you offer to write any on their in-game dialog? ;)

I love that they're in the game! It's fantastic whenever one of my creations becomes a part of Azeroth! It gives them a sort of immortality.

I'd have liked to write some of the dialogue, but I leave that in the hands of the fine folks at Blizz.

Your scripts are very well researched. I know you play WoW, but what other sources do you draw from?

In addition to playing, I'm constantly in contact with the publishing lead and the folks in Lore. Azeroth is a big world and with all going on in it, it's always good to have their help.

Let's talk about dragons! Clearly, you have an affinity for them--as evidenced by *The Sunwell Trilogy*, the two *Dragons of Outland* manga and the *Mage* class-based manga that you also wrote. What do you personally find so appealing about these beasts?

They are to me, along with wizards, the epitome of magic and fantasy. They are powerful, fantastic creatures with so many variations these days. They add an epic feel to any story in which they are part.

Is it going to be difficult leaving Jorad and Tyri behind? If their story continued, where would you take them? What else would you want to explore with these two?

It's rough to leave them where they are. I'd like to explore what happens next, such as how she'll guide the new nether dragons, what trials she and Jorad will face, and who might try to interfere with what Tyri's trying to do. Maybe some day. ☺

Thanks for creating such a memorable manga series, Richard! Do you have any final words you'd like to say about working on such an epic storytelling endeavor?

It always a pleasure to come back to Azeroth and with the mangas, I've been able to see the story come to life in a whole new way. I'm happy so many people enjoyed the tales!

STARCRAFT

GHOST ACADEMY

VOLUME 3

Ghosts are the Dominion's ultimate weapons - elite terran operatives capable of reading thoughts, becoming invisible, and much more. One location possesses the technology and expertise required to teach these mysterious individuals their unique and deadly talents: the Ghost Academy.

Struggling to forget her harrowing past, Nova, a powerful psionic soldier-in-training, has found strength in her fellow trainees: Tosh, a hard-line Dominion supporter; Kath, a mouthy vice-president's daughter; Delta, a bubbly newbie; and Lio, a scatter-brained techno-path. Together, Nova and her teammates undergo brutal physical and psychological exercises as their unique telepathic and telekinetic powers are twisted to serve the Dominion.

Having proven themselves at the academy, Nova and her team are dispatched to an abandoned mining planet for a real-world training exercise...

Available Now!

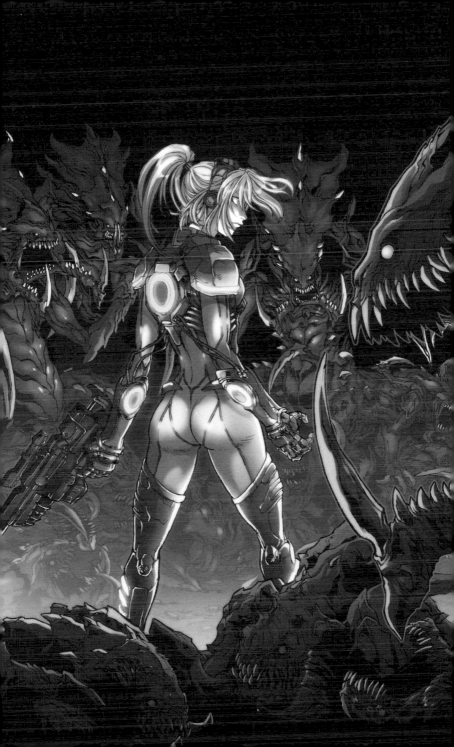

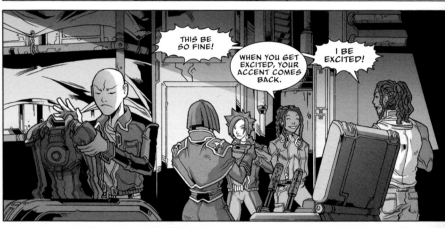

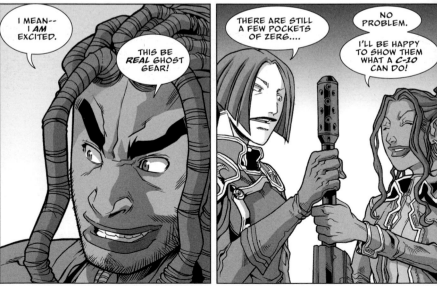

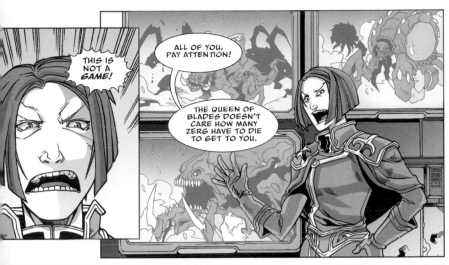

THIS IS NOT A **GAME!**

ALL OF YOU, PAY ATTENTION!

THE QUEEN OF BLADES DOESN'T CARE HOW MANY ZERG HAVE TO DIE TO GET TO YOU.

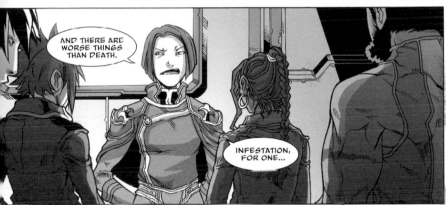

AND THERE ARE WORSE THINGS THAN DEATH.

INFESTATION, FOR ONE...

WE HAVE ORDERS NOT TO LET THAT HAPPEN.

ONE WAY OR THE OTHER...

WE'RE GOOD.

WE WATCH EACH OTHER'S BACKS.

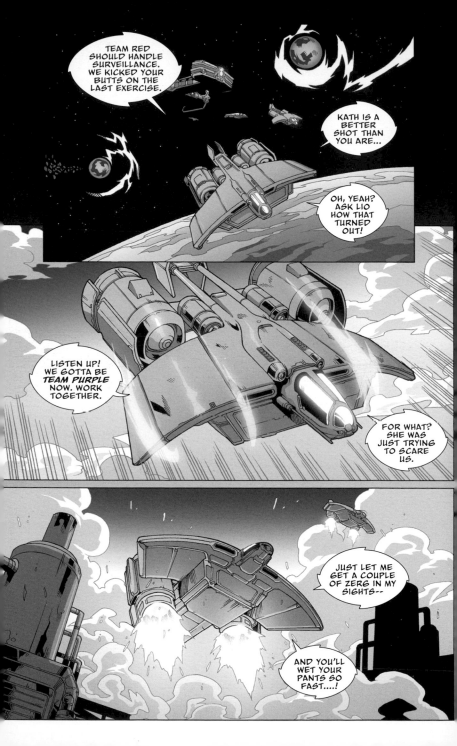

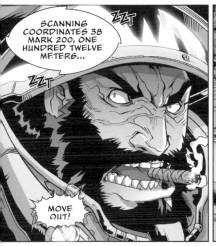

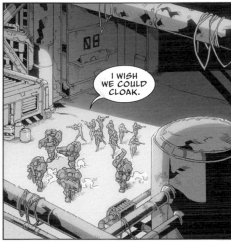

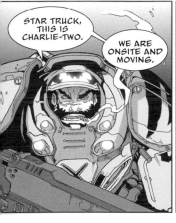

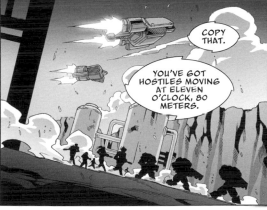

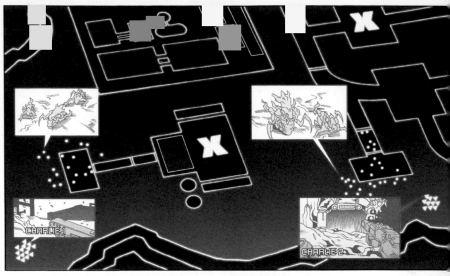

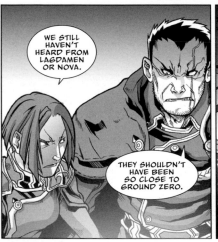

WE STILL HAVEN'T HEARD FROM LAGDAMEN OR NOVA.

THEY SHOULDN'T HAVE BEEN SO CLOSE TO GROUND ZERO.

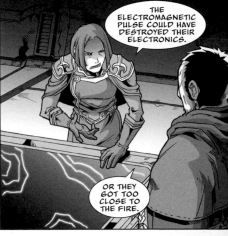

THE ELECTROMAGNETIC PULSE COULD HAVE DESTROYED THEIR ELECTRONICS.

OR THEY GOT TOO CLOSE TO THE FIRE.

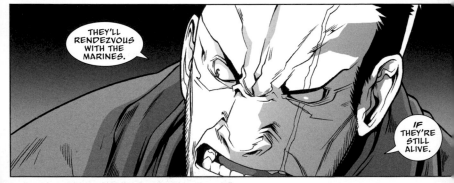

THEY'LL RENDEZVOUS WITH THE MARINES.

IF THEY'RE STILL ALIVE.

CHARLIE-ONE. REPORT.

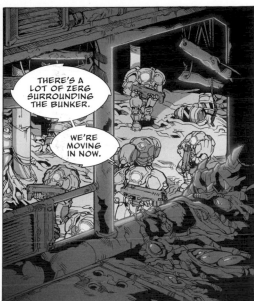

THERE'S A LOT OF ZERG SURROUNDING THE BUNKER.

WE'RE MOVING IN NOW.

I'M PICKING UP TARGETS AT FOUR O'CLOCK.

A LOT OF THEM. TEN MINUTES OUT.

WHERE ARE THEY ALL COMING FROM?

WIDENING THE SCAN...

CHARLIE-TWO. REPORT.

WE'RE ABOUT TO ENGAGE!

HOLY FEKK!!

THERE'S ANOTHER CLUSTER OF HATCHERIES!

AT THE EDGE OF OUR SCANNING RANGE!

BIGGER THAN THE FIRST! ON THE FAR SIDE OF MANDIBLE CANYON!!

BOTH SQUADS!! LINK UP AT THE DROP ZONE!

YOU'VE GOT *SIX* MINUTES!!

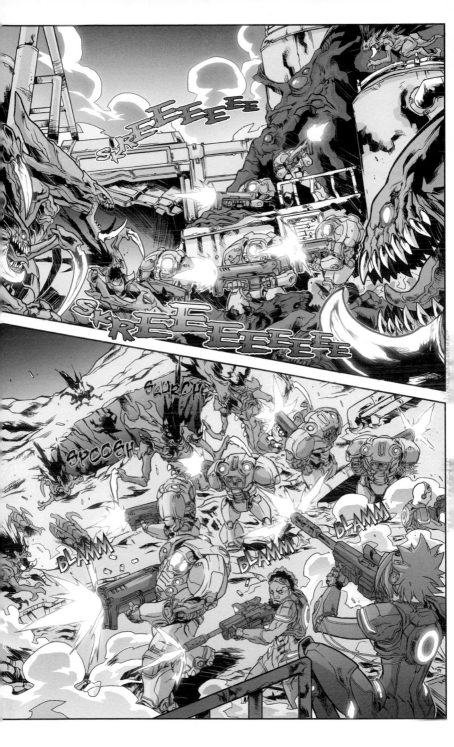

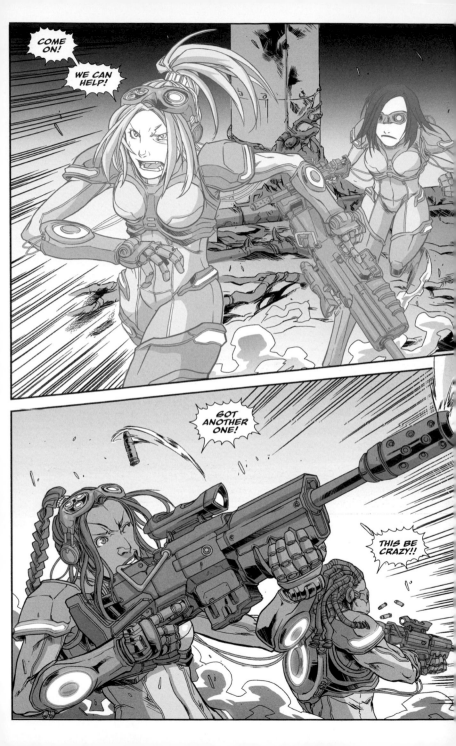

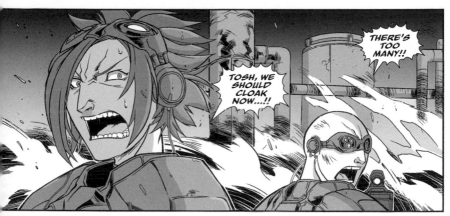

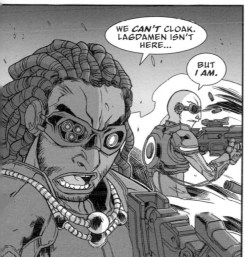

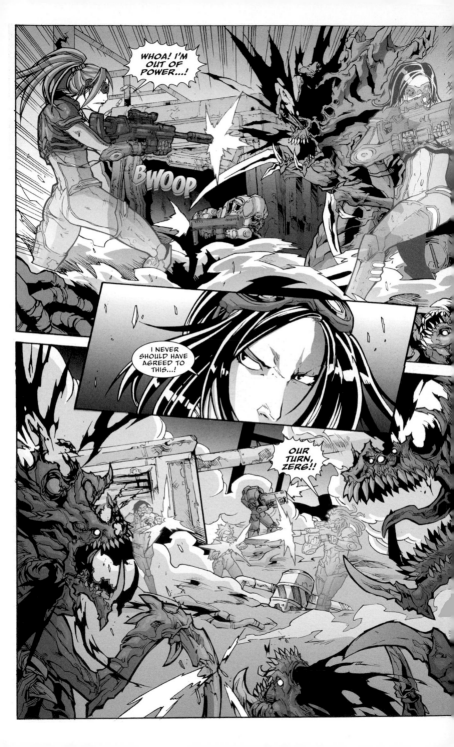

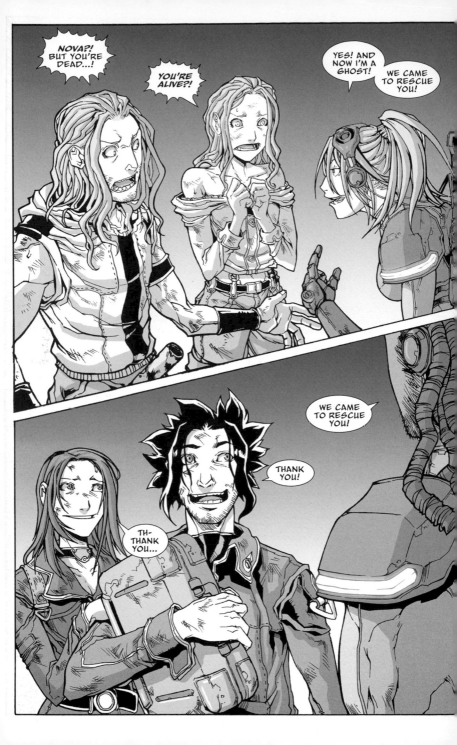

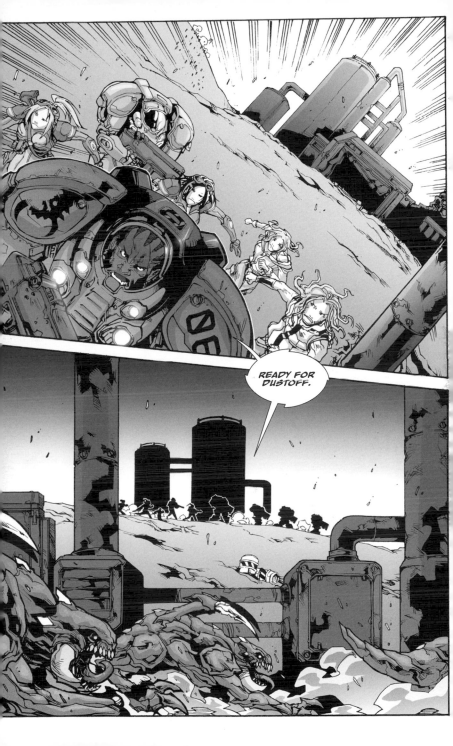

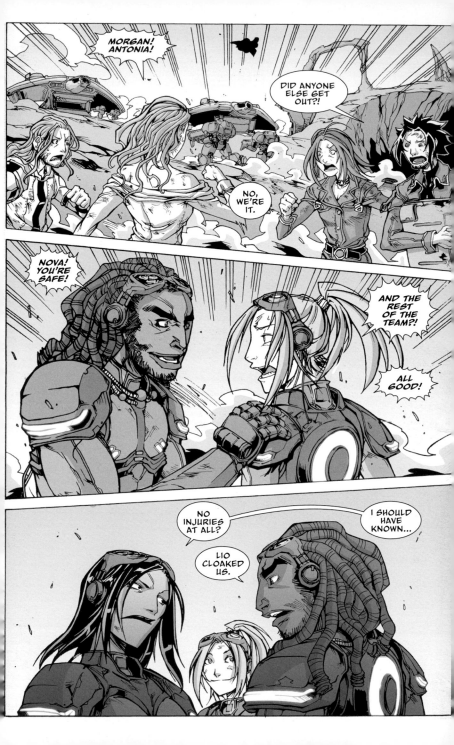

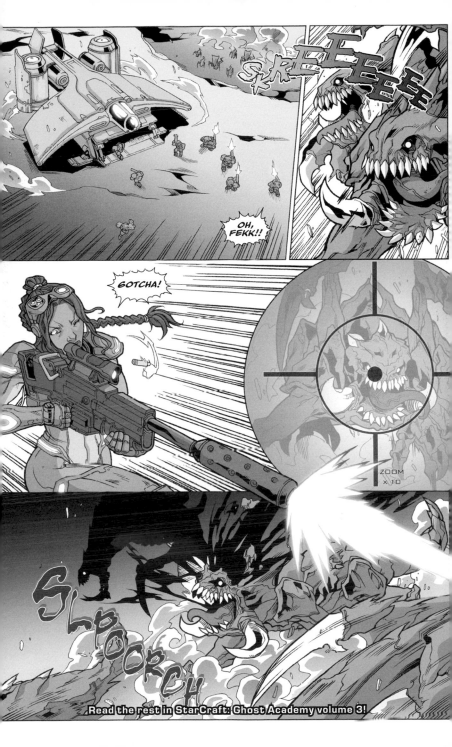

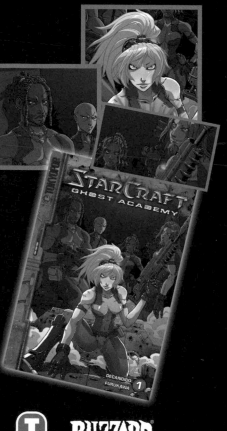

LEVEL UP

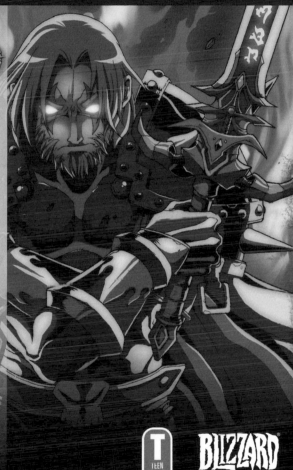

When called upon to battle the Scourge army, Thassarian sees his chance to prove to others—and himself— that he has what it takes to follow in his deceased father's heroic footsteps.



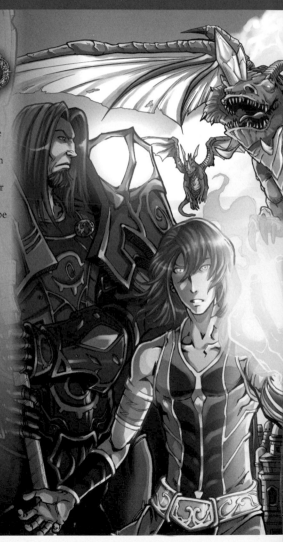